KB126653

김 생 화

Kim, Saeng-Hwa

WWW.HEXAGONBOOK.COM

이 도서의 국립중앙도서관 출판예정도서목록(CIP)은 서지정보유통지원시스템 홈페이지(http://seoji.nl.go.kr)와
국가자료종합목록 구축시스템(http://kolis-net.nl.go.kr)에서 이용하실 수 있습니다. (CIP제어번호 : CIP2020019639)

한국현대미술선 047
김생화

2020년 5월 13일 초판 1쇄 발행

지 은 이 김생화
펴 낸 이 조동욱
기 획 조기수
펴 낸 곳 출판회사 헥사곤 Hexagon Publishing Co.
등 록 제2018-000011호 (등록일: 2010. 7. 13)
주 소 경기도 성남시 분당구 성남대로 51, 270
전 화 010-7216-0058, 010-3245-0008
팩 스 0303-3444-0089
이 메 일 joy@hexagonbook.com
웹사이트 www.hexagonbook.com

ⓒ 김생화 2020, Printed in KOREA

ISBN 979-11-89688-33-2
ISBN 978-89-966429-7-8 (세트)

김 생 화

Kim, Saeng-Hwa

HEXAGON
Korean Contemporary Art Book
한국현대미술선 047

아
Ego
我

자아의 인식

김생화는 이국타향 중국에서 십여 년의 시간을 보냈다. 이 과정은 어떤 동기나 목적이 있었든 간에 본인의 완강한 의지가 있어야 했을 것이다.

그의 작품을 네 가지로 나누어 보면: 첫 번째, 한국에서 제작하고 현실을 주제로 구체적 관념을 사실적 이미지로 전달한 작품이다. 예로 〈돈이 뭐길래〉라는 작품을 보면, 돈에 대한 욕망을 세밀하고 조밀하게 얽혀있는 인간들로 표현했는데, 이러한 복잡한 형태와 선명하고 풍부한 유약의 색감은 유럽과 미국 현대 도자의 특징과 비슷하다. 두 번째는 중국 칭화대학 대학원 재학 중 현실주의에 영향을 받아 비교적 직관적 표현을 보여준 작품으로, 북경의 한국 유학생들의 모습을 소재로 하기도 했다. 세 번째는 이국적인 삶에 대한 호기심을 경험했던 포산 스완(佛山石湾)에서 6년 동안 제작한 작품으로, 전통 스완 와지공자이의 제작 기법을 깊이 연구하고, 그 기법을 사용해 임진왜란을 소재로 작품 〈행주대첩〉 등을 제작하기도 했다. 동시에 같은 기간 동안 제작한 〈숲속의 교향악〉은 이전 작가 개인의 내면적 정서의 기록이 인성과 생명의 본질에 대한 사고

로 변하는 과정을 분명히 보여주었다. 거대한 〈숲속의 교향악〉을 마주한 우리는 가슴 벅찬 감동을 느꼈다. 작품의 지성과 기발함뿐만 아니라 그 탄생이 얼마나 쉽지 않은지, 얼마나 많은 육체적인 노력을 기울였는지 가늠하는 것만으로도 충분한 감동을 받을 수 있었다. 네 번째는 전시 〈너 자신을 봐봐〉의 작품들이다. 일상생활에 있어서 국가의 신분은 그에게 가장 중요한 문제가 아닐 수도 있지만, 예술가로서 그가 가장 중요하게 여기는 것은 통상적 의미의 '인간'에 대한 사고이다. 인간인 자신이 가진 '면(외면)'과 '안(내면)'의 양면성을 통해, '인간 내면의 복잡성과 은유를 어떻게 가장 잘 해석할 수 있을까?'에 대해 고민했다. 김생화는 정체성과 자아를 인식할 뿐만 아니라, 예술가로서 깊은 고민을 하며, 자신의 내면에 있는 삶을 충실히 따르고, 인간 본성에 대한 풍부한 감수성을 가지고 있다.

일종의 예술의 형식이나 방법에는 반드시 그에 따른 언어 환경을 가지고 있기 때문에, 그것을 읽고 이해하는 능력이 필요하다. 사실 중국과 한국은 서로 다른 독특한 시각적 언어표현

방식을 가지고 있다. 김생화의 조소 능력은 세계 최고라고 할 만하다. 그녀의 손안에 있는 흙을 보고 있으면, 마치 자유분방한 붓을 보는 것 같고, 그 조소의 형상은 중국 전통 성어 "흉유성죽(胸有成竹-대나무를 그리기 전에 이미 마음속에는 대나무의 형상이 있다-일을 하기 전에 이미 모든 준비가 되어있음을 뜻함)"뿐 아니라, 개울물이 자유롭게 유동하는 모습과도 같고, 청명한 한국인의 기질을 가지며, 자신도 모르게 계속되는 마음속 감회를 생명의 반복으로 표현해 낸다. 때로 당신이 그의 생각을 이해한다고 생각할 수 있으나, 때로는 마치 주변 경관을 한눈에 관조하고 있는 사람과 같아서 아무리 자세히 살펴도 무슨 생각을 하고 있는지 알 수 없다. 오랜 시간 동안 실재 타지에서 생활하고 있는 나그네로서, 그 내면의 분열을 다면적으로 구성하여 온전한 "자신"을 표현했다. 외모를 보면, 그는 한국인이 아니고 '북방인'으로 여겨지기도 한다. 그러나 다른 문화에서 성장하였고, 누구보다 한국 민족의 기질을 뚜렷하게 가지고 있다.

20대의 한국인 소녀는 이미 십어 년 넘게 중국에서 풍부하고 다채로운 타국생활을 경험했고, 현재 광저우 미술대학의 외국인 전임 교수로 재직하고 있다. 진정한 예술가는 세속에 물들지 않고, 결코 명예를 좇지 않으며, 동시에 그에 따른 사명과 책임감을 가진다. 그는 교사로서 자신의 창작 경험과 연구 성과를 강의로 실천하고 있으며, 두말할 것 없이 그것은 우리를 감동시키고 부끄럽게 한다.

"세상에서 가장 중요한 것은 자아(自我)를 인식하는 것"이며, 그 "아(我)"는 바로 김생화 자신이다. (2018.1)

Recognition of Ego

Hua Wei
Professor at Guangzhou Academy of Fine Arts

Saenghwa Kim spent nearly a decade in the foreign land of China. This lengthy sojourn abroad, regardless of the motive or purpose, must have required a great deal of determination on her part.

Her works of art can be divided into four categories. The first category includes those she made in Korea under the theme of reality, conveying concrete ideas into realistic images. In her work titled "What Is Money?" for instance, the desire for money is expressed as human beings entangled in a dense and intricate mesh. These complicated forms and vivid and richly-colored glaze bear resemblance to the characteristics of modern ceramics in Europe and the U.S. The second category was created during her time studying for her MFA at Tsinghua University, China, where she portrayed Korean students studying in Beijing rather intuitively under the influence of realism. The third category refers to the works she produced over six years in Shiwan, Foshan, China, as she lived out her curiosity toward a different way of life. During her stay in Shiwan, a renowned Chinese ceramics town, she intensively studied the unique techniques used in Shiwan ceramic figurines, and by using these techniques,

created a work titled "Battle of Haengju," inspired by the Japanese invasions of Korea in 1592. Another work produced during this period, "Symphony of the Nature," clearly illuminates the transition from the artist's personal documentations of her inner emotions to thoughts on human character and the nature of life. When encountering with this magnificent work, the audience felt overcome with emotion. The audience was deeply impressed by the sheer intelligence and ingenuity found in the work, but also by how challenging it was for this work to be created, and how much physical effort she had exerted. The fourth category is characterized with works presented at the exhibition, "Look at Yourself". Nationality may not be of the greatest importance to her in her daily life, but what matters most as an artist is the way to consider "humans" in the conventional sense. Saenghwa Kim pondered on how to interpret the complexities and metaphors hidden in the inner side of the human beings through the duality of her façade (external aspect) and her inside (internal aspect). Fully aware of her identity and ego, while deeply contemplating the issues that she faces as an artist, Saenghwa Kim faithfully follows

her inner voice and demonstrates robust sensibilities with regard to human nature.

In general, formats and methods of creating art inevitably entail their own linguistic environment, which requires the ability to read and understand it. Indeed, Korea and China have their own unique expressive mechanisms for visual language. When it comes to the ability to create formative art, Saenghwa Kim is among the best in the world. Simply looking at the clay in her hands reminds us of freewheeling brushstrokes on the canvas, while Saenghwa Kim's ceramic forms recall a Chinese traditional saying, "to have a well-thought-out plan (胸有成竹)," or in other words, having the form of a bamboo tree ready in one's mind before actually painting it. It also evokes the image of a free-flowing brook. The artist is known for her high spirits and clarity, typical of the Korean temperament, and expresses emotions that unwittingly grow in her heart into the cycle of life. Viewers might think at some point that they can understand what is in her mind, but would be completely lost in other aspects, unable to garner even an inkling of the artist's thoughts despite the closest attention, because she herself seems to be a spectator as if contemplating the surrounding landscape at a glance. As a traveler who lived in a foreign land for a long time, she portrays an entire "self" by arranging her inner fragmentations from multiple angles. By appearance, she would sometimes be viewed as a Northern Chinese, rather than a Korean. However, Saenghwa Kim grew up in a different culture and she has much of the distinctly typical Korean character.

The Korean girl, who was then in her twenties, came to garner myriad experiences in China during a stay of over a decade and now works as a full-time professor at Guangzhou Academy of Fine Art. A true artist is one who is neither tainted with worldly desires nor chasing after fame, but rather has a sense of calling and responsibility. As a teacher, she dedicates her research achievements into practice, which undoubtedly both awes and shames many of us.

"What matters most in the world is to recognize the ego." By "ego", Saenghwa Kim refers to herself. (2018. 1)

认识自我

魏华
广州美术学院工艺美术学院副院长

金生花在中国已经十几年了，异国他乡，无论是出于什么动机和目的也该具有足够的毅力。

追踪她的艺术线路大致分为四个阶段：在韩国硕士学习期间多表达现实的现状、用一种意像的写实表达一种具体的观念，如《到底钱是什么？》非常细腻的把人们面对金钱的情态充分表达，釉色鲜艳、丰富、有着明显的欧美造像风格；第二阶段，在清华学习阶段，作品明显受到"现实主义"的影响，比较直观的表达韩国人在北京的生活状态；第三阶段，在石湾的六年，明显经历了对异域生活的好奇，她对石湾瓦脊构图方式做了很认真的研究，用瓦脊的方式创作了反映韩日战争题材的作品《幸州之战》。同时期创作的《林中交响音乐会》明显已从之前对个人内心情绪的记录转变到了对人性，生命本质的思考。面对庞大的《林中交响音乐会》我们内心无不有一份感动，我们都知道这些作品的诞生多么的不容易，不光是其心智，奇思妙想，哪怕就其体能的付出也足以让人感动；第四阶段，就是《看看你自己》这批作品的创作，对于日常生活而言，国家的身份也许并不是她最关切的问题，作为艺术家的她，对通常意义上的"人"的思考才是最关键的所在。作为人的自己"面"与"里"的两面性，人的内心的复杂性与隐喻怎么才是最佳的解读呢？除了身份还有对自我的认知，作为艺术家，金生花的思考无疑是深

刻的，她遵循着自己内心生活真实的感受，对人性的感受力亦是丰富的。

一种艺术形式或方式一定得拥有一种语境，你得具备一些读懂的能力，实际上中国、韩国各自拥有自己独特的视觉语言方式，金生花的陶塑能力堪称世界一流，有时观看她捏手中的泥巴，就像自由奔放的画笔，其形象的塑造并不是我们中国传统意义的"胸有成竹"，而是像溪流自由流淌，也清澈的呈现着韩国民族的特质，展示她内心感怀、沉淀生命的悲切。有时观者会觉得清楚的明了她内心的所思，有时又觉得她的内心观照又很遥远，好像在俯视静观周围的一切；当然更多的是一个真实的活生生的生活在异域流浪的游子，其内心分裂与多面构成了一个完整的"我"。从外貌而言她甚至不算太韩国，有时更多的被认为是"北方人"，但她毕竟是在不同文化背景成长起来的人，有着很明显的韩国民族的特质。

一个二十多岁的韩国女孩在中国已经历了十几年丰富多彩的异国生活，今天她已是广州美术学院外聘专家、专职教授。真正艺术家的超凡脱俗并不在于他们不追求名利，而是他们还兼具使命和责任。作为一个教师，她把对自己研究成果转换成教学实践，无疑也让我们感动而又汗颜。

"世上最重要的事情就是认识自我"。

"我"就是金生花。

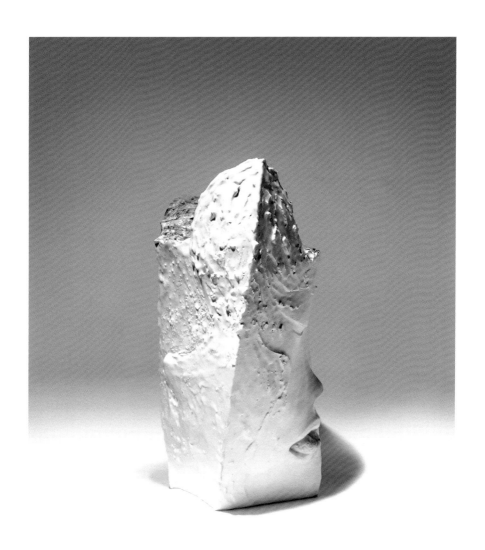

Nyah 43×45×50cm Ceramics 2018

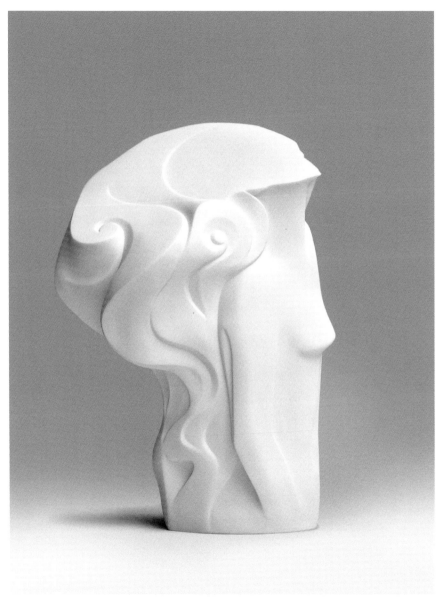

11 十一流　24×19×35cm　Ceramic, 1320 degree firing　2019

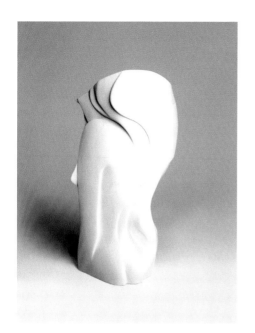
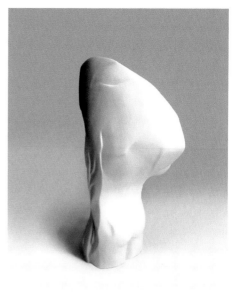

11 十一流 (Back and side)

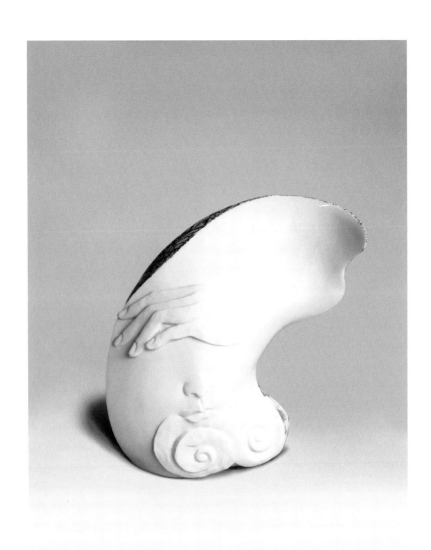

Wind 30×13×35cm Ceramic, 1320 degree firing 2019

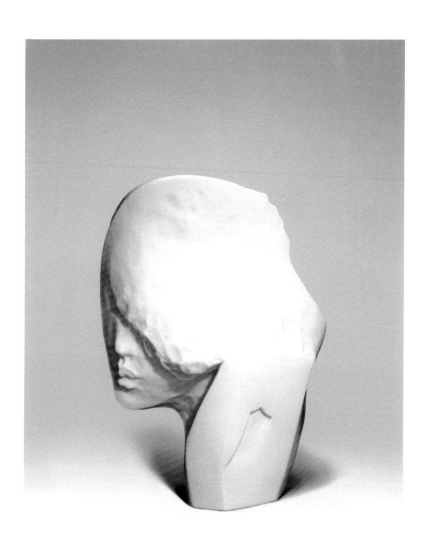

Cry & flow – 2019 25×12×30cm Ceramic, 1320 degree firing 2019

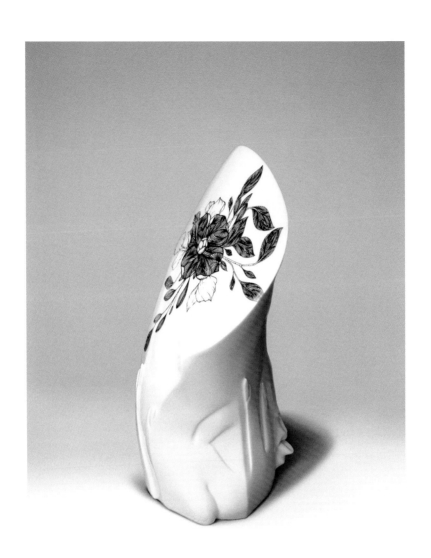

What – 2019 (Side)

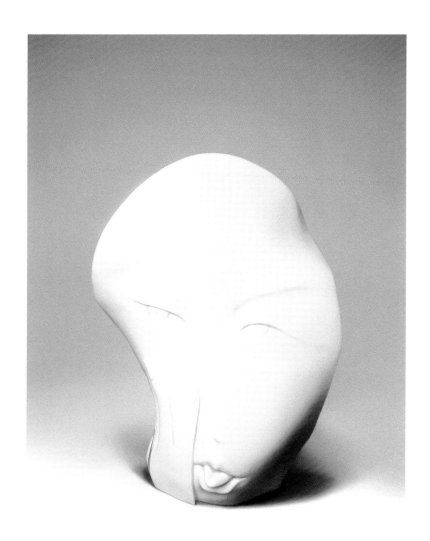

What – 2019 25×18×35cm Ceramic, 1320 degree firing 2019

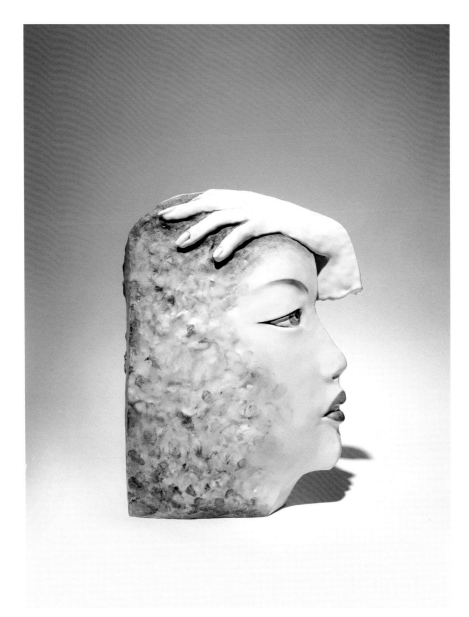

Ja 23×12×35cm Ceramic, Silver leaf, Glaze, Oil painting 2018

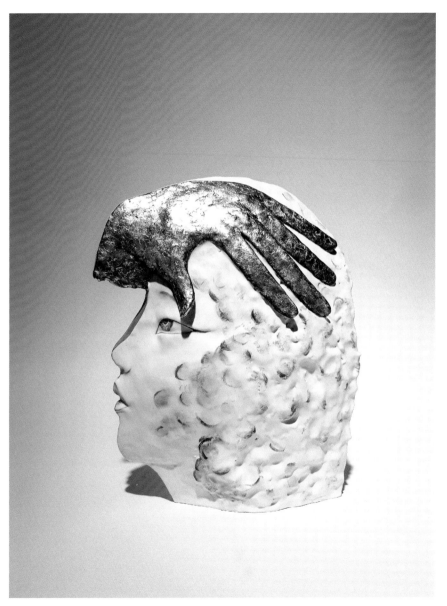

Ja (Back)

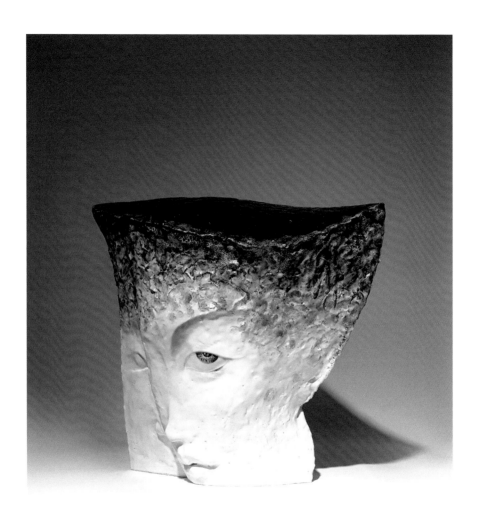

Na 50×30×75cm Ceramics 2018

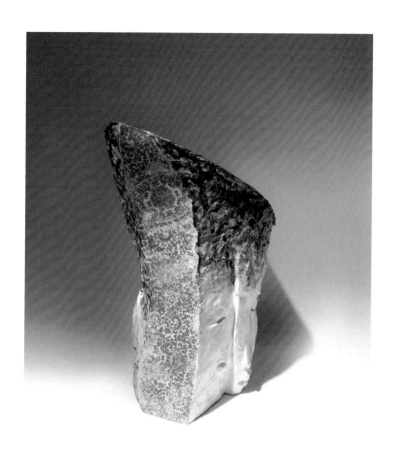

Na (Side)

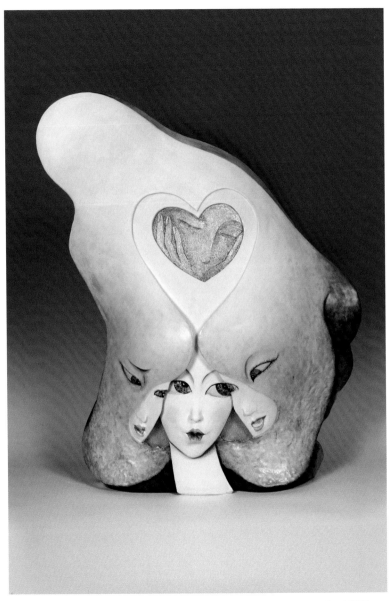

Self discovery 60×32×85cm Chinese Lacquer, Ceramic, Silver leaf, Oil painting, Pearl 2017

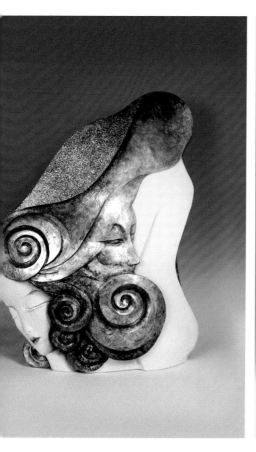
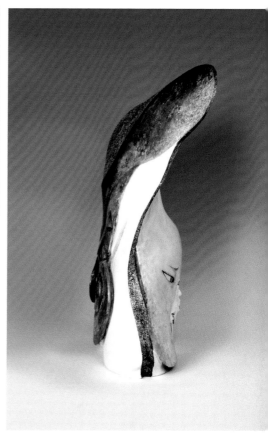

Self discovery (Back and side)

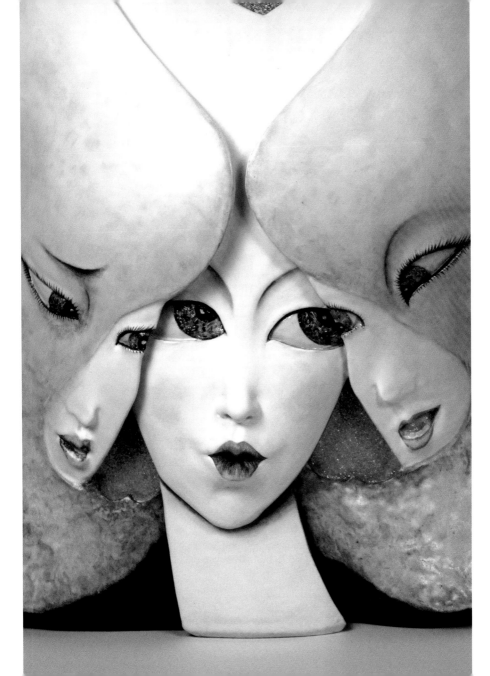

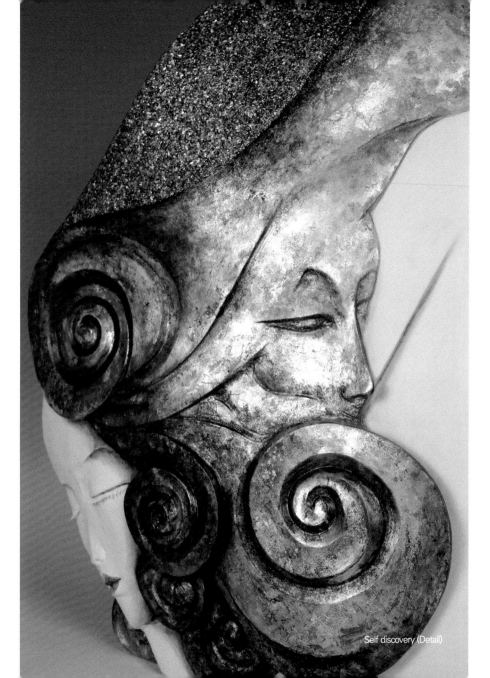

Self discovery (Detail)

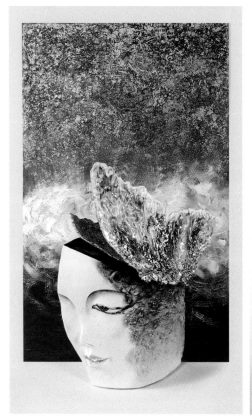

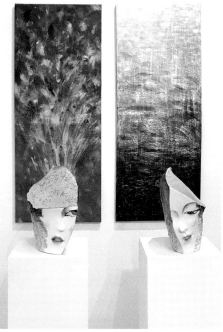

Jinhua
65×106, 42×30×50cm
Chinese Lacquer, Ceramic, Gold leaf, Pearl, Oil painting
2018

Nine red + Nine blue
46×110cm(ea), 33×23×33cm(ea)
Chinese Lacquer, Ceramic, Gold leaf, Silver leaf, Pearl, Oil painting
2018

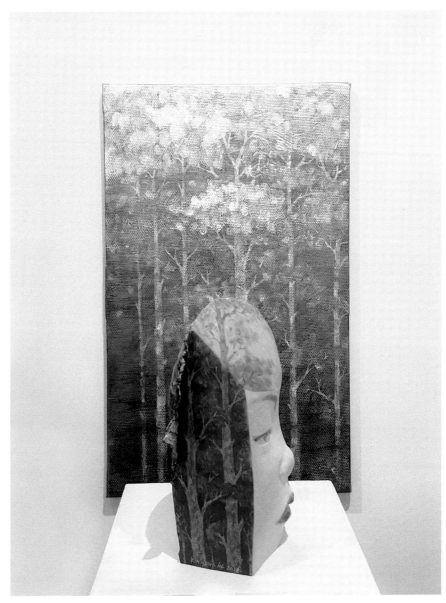

K-young 41×63cm, 22×13×30cm Ceramics, Oil painting 2018

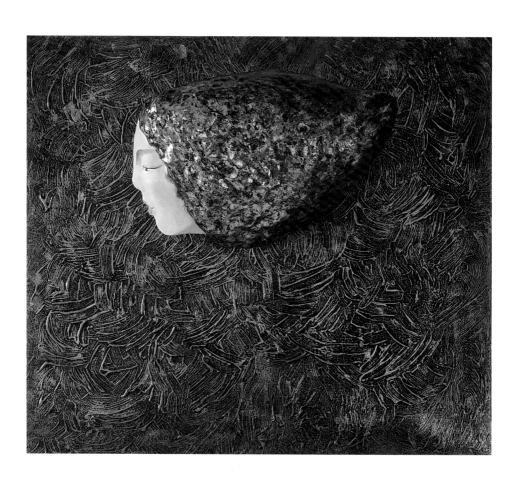

Y-eun 53×45×11cm Ceramic, Gold leaf, Oil painting 2018

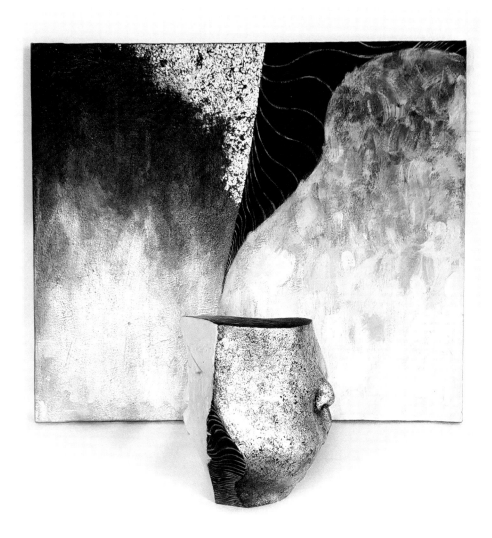

Y-mok 53×46cm, 22×18×20cm Ceramic, Gold leaf, Silver leaf, Glaze, Oil painting 2018

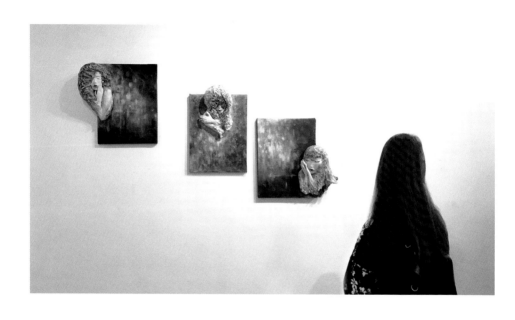

Blue Yellow Green 50×41×13, 42×57×10, 52×41×11cm Ceramic, Oil painting 2018

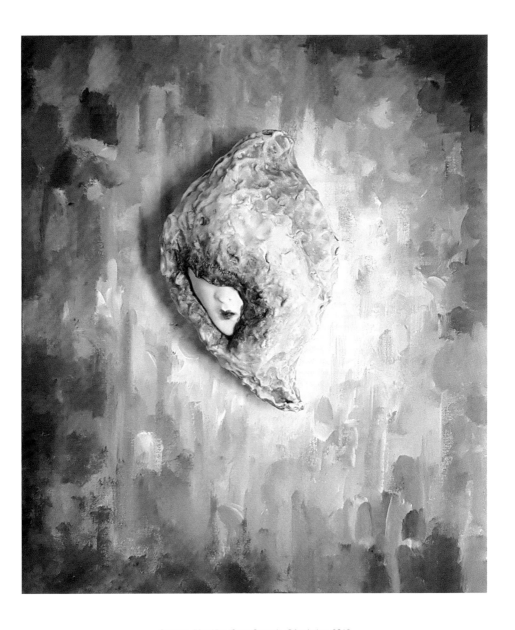

Comma 53×45×10cm Ceramic, Oil painting 2018

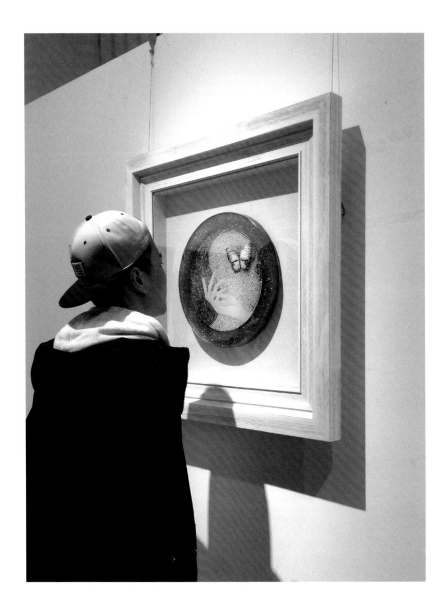

Everyday 90×90×20cm

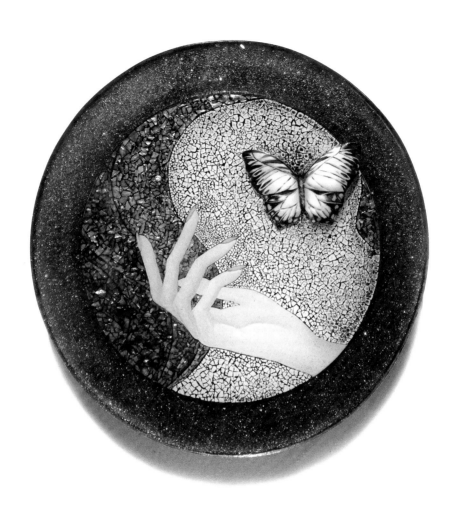

Everyday 42×42×10cm
Chinese Lacquer, Ceramic, Resin, Shimmer powders, Pearl, Glass, Oil painting, Wooden board 2017

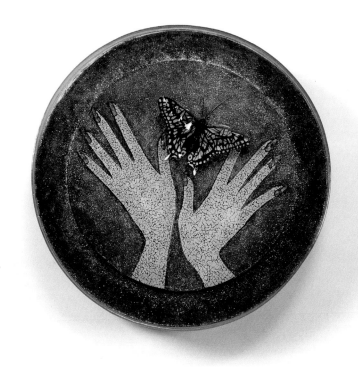

Wed.-joy 42×42×10cm
Chinese Lacquer, Ceramic, Resin, Shimmer powders, Pearl, Glass, Oil painting, Wooden board 2017

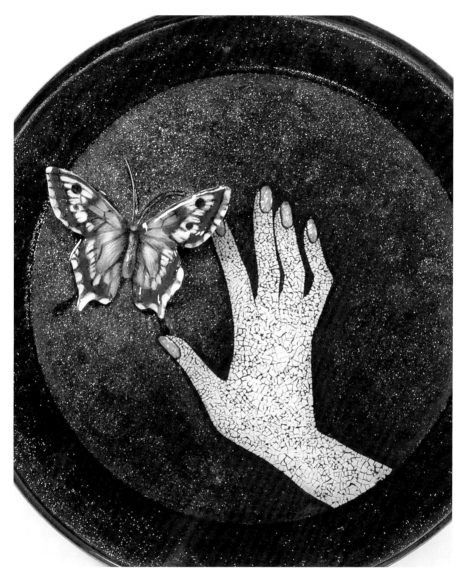

Fri.-ownership 42×42×10cm
Chinese Lacquer, Ceramic, Resin, Shimmer powders, Pearl, Glass, Oil painting, Wooden board 2017

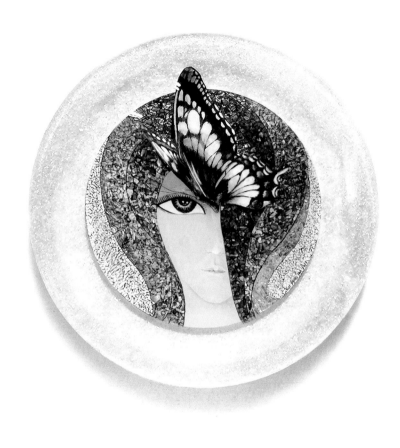

Sat.-awake 50×50×12cm
Chinese Lacquer, Ceramic, Resin, Shimmer powders, Pearl, Glass, Oil painting, Wooden board 2017

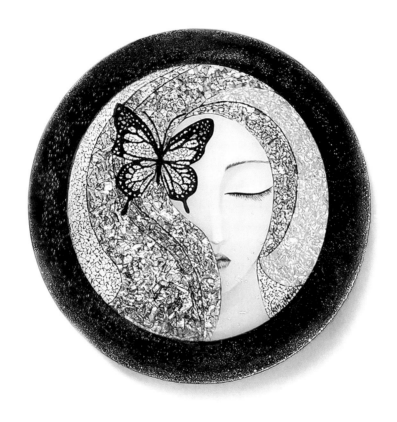

Sun.-dream 50×50×12cm
Chinese Lacquer, Ceramic, Resin, Shimmer powders, Pearl, Glass, Oil painting, Wooden board 2017

Tue.-valuable 42×42×10cm
Chinese Lacquer, Ceramic, Resin, Shimmer powders, Pearl, Glass, Oil painting, Wooden board 2017

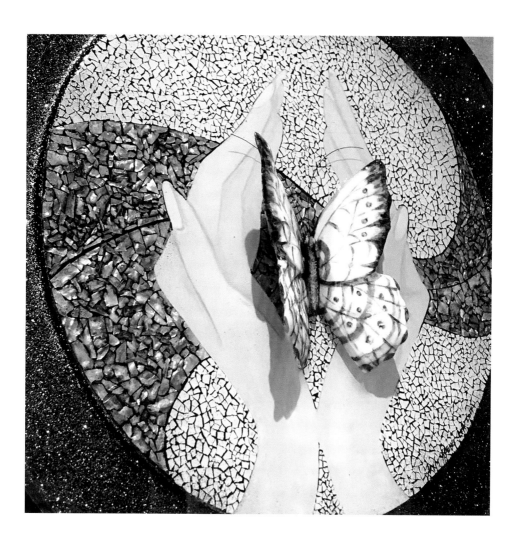

Tue.−valuable (Detail)

I don't watch! 30×18×38cm Ceramic, Glaze, Gold leaf, Silver leaf, Swarovski crystal, Oil painting, Pearl 2017

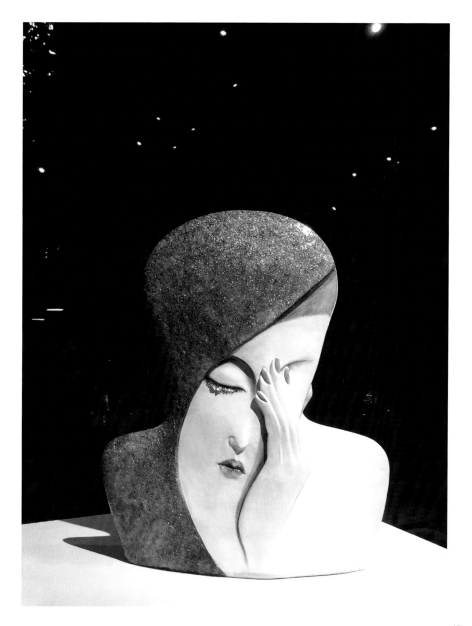

경계인
Marginal Men
境界人

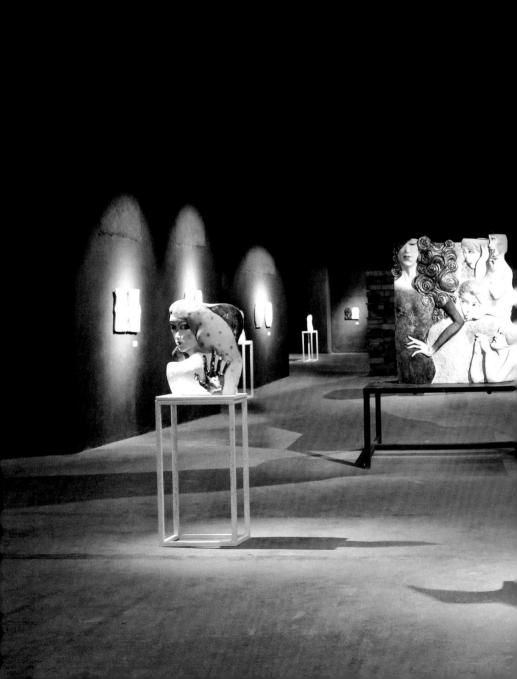

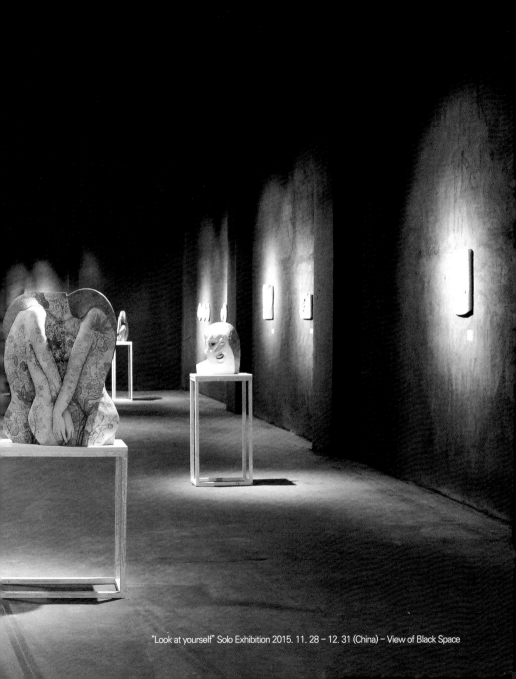

"Look at yourself" Solo Exhibition 2015. 11. 28 – 12. 31 (China) – View of Black Space

"Look at yourself" Solo Exhibition – View of Black Space

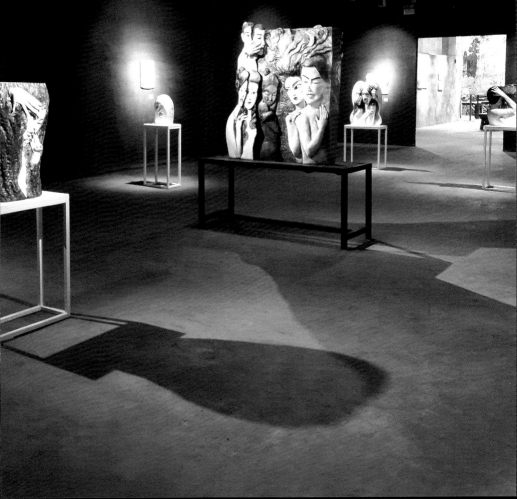

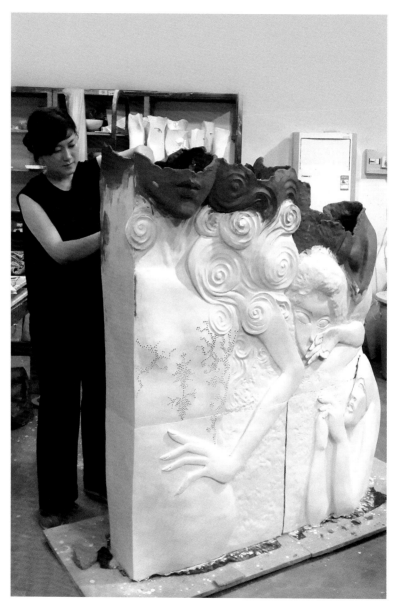

The process of making 'Look at yourself'

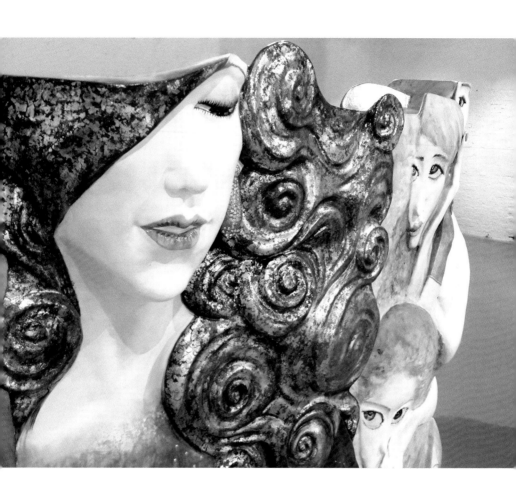

Look at yourself
135×42×145cm Ceramic, Gold leaf, Silver leaf, Copper leaf, Swarovski crystal, Glaze, Oil painting 2015 (Detail)

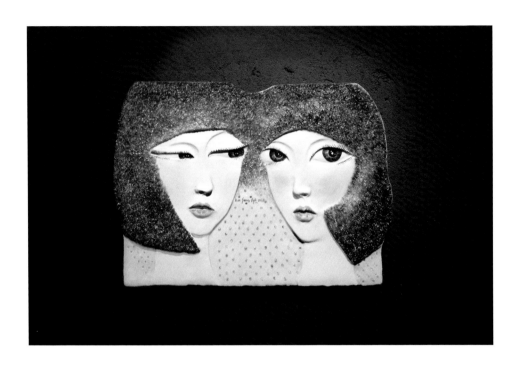

Bobbed hair 50×36×6cm Ceramic, Pearl, Swarovski crystal, Oil painting 2015

Cry & flow 65×48×4cm Ceramic, Pearl, Oil painting 2015

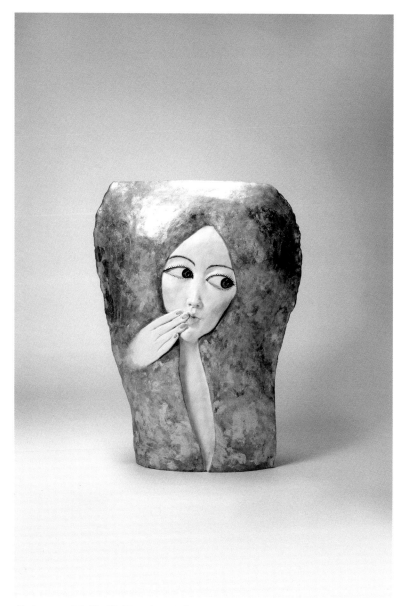

Don't want to do it 55×25×73cm Ceramic, Gold leaf, Silver leaf, Swarovski crystal, Oil painting 2015

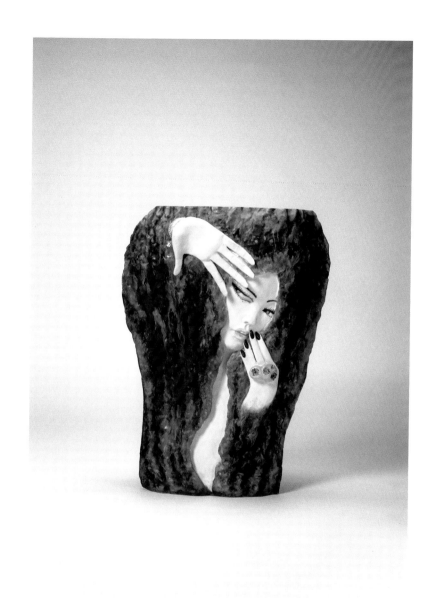

Don't want to do it (Back)

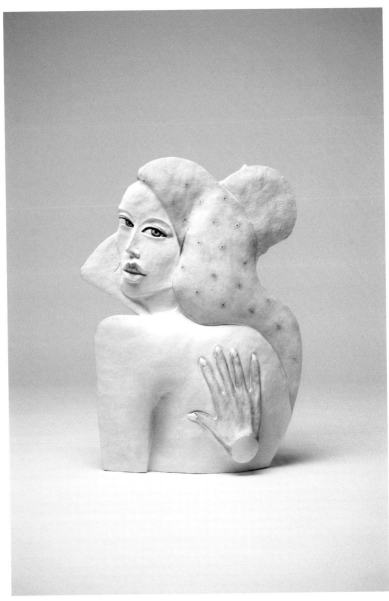

Coercion & Troublesome 42×7×56cm Ceramic, Oil painting 2013

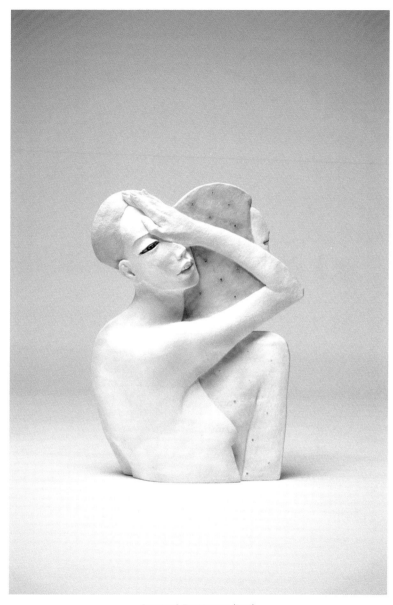

Coercion & Troublesome (Back)

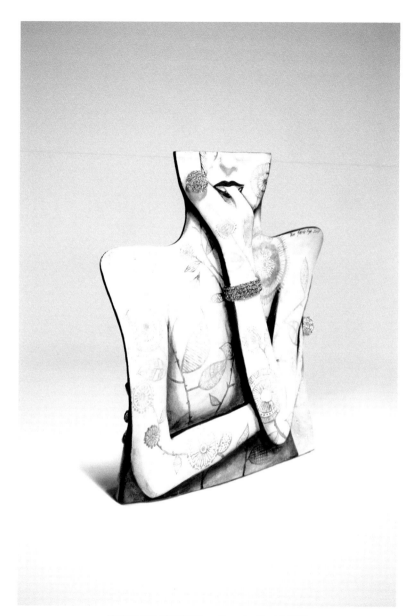

Hesitate 犹豫 50×22×51cm Ceramics, Crystal 2015

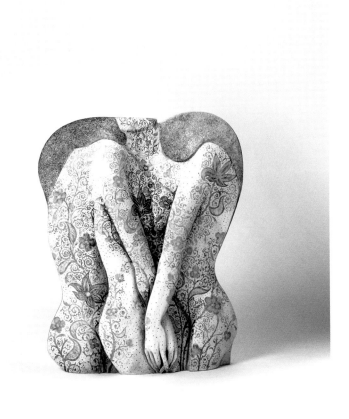

Listen 80×30×80cm Ceramic, Glaze, Pearl, Oil painting 2015

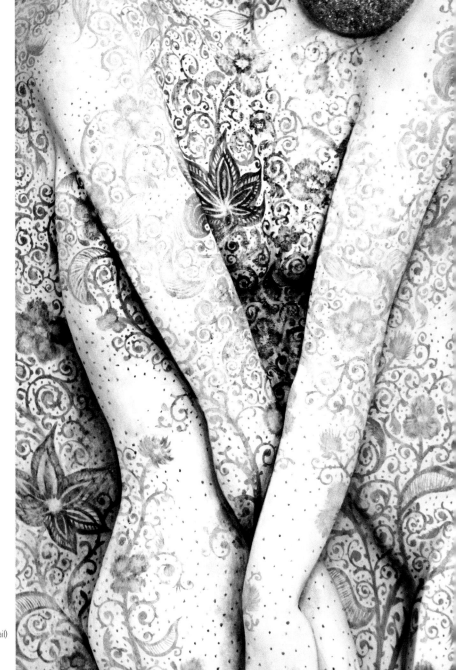

Listen (Detail)

"Look at yourself" Solo Exhibition 2015 – View of White Space

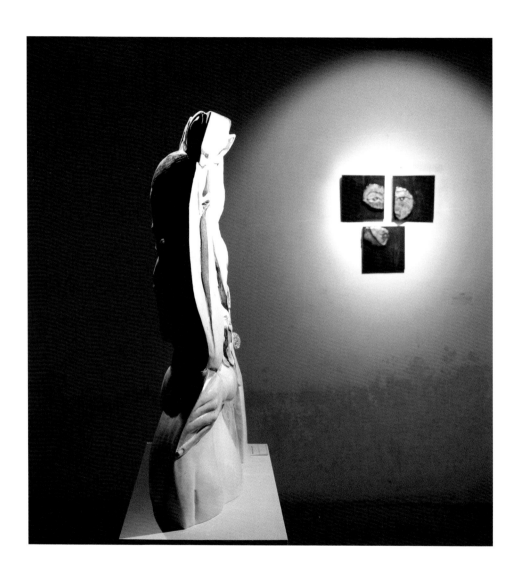

Man and Woman (Side)

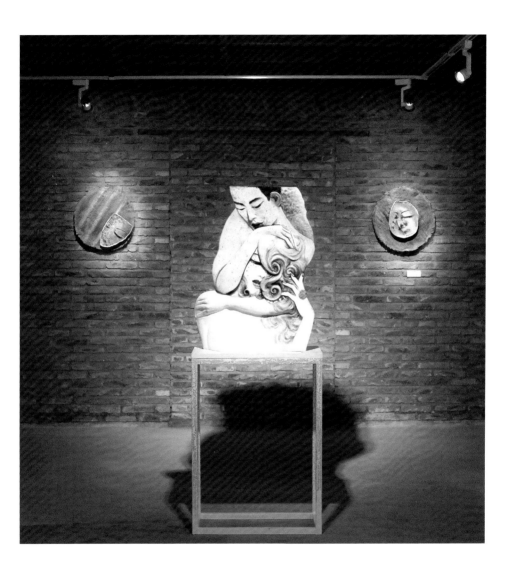

Man and Woman 60×25×80cm Ceramic, Swarovski crystal, Oil painting 2014

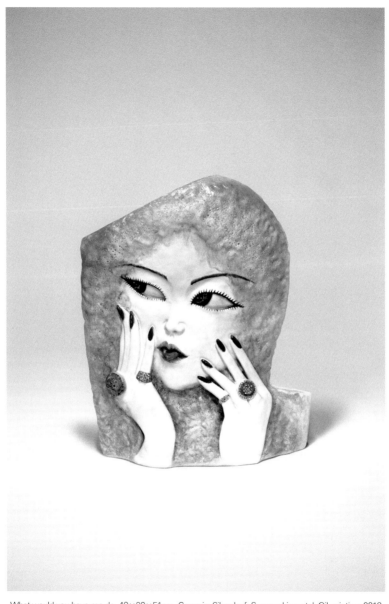

What would you have me do 40×20×51cm Ceramic, Silver leaf, Swarovski crystal, Oil painting 2013

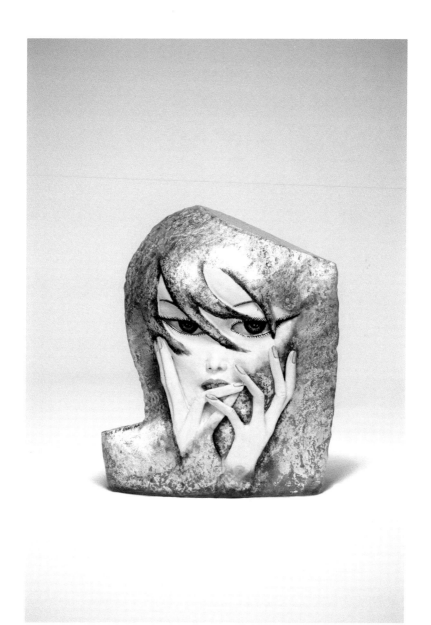

What would you have me do (Back)

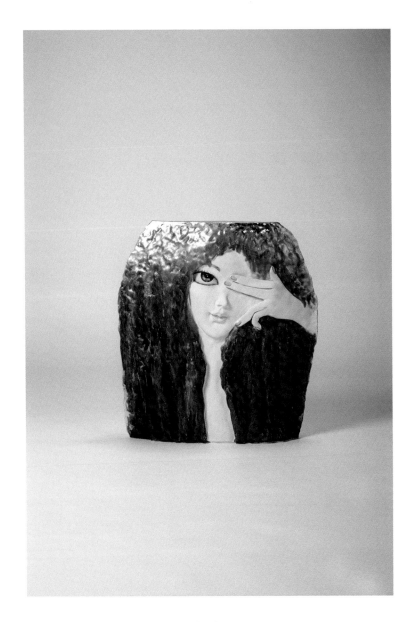

不想看 + 不能看 Don't want to see + Can't see (Back)

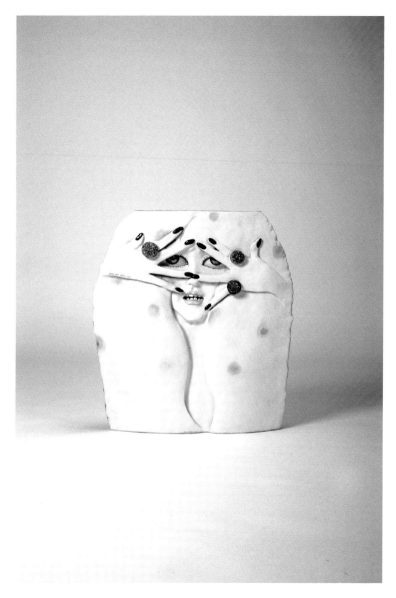

不想看 + 不能看 Don't want to see + Can't see
53×20×55cm Ceramic, Gold leaf, Swarovski crystal, Oil painting 2013

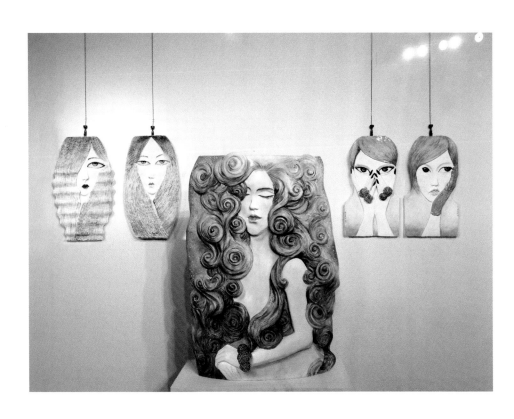

(L) Perm 30×50×6cm(ea) Ceramic 2014
(C) Rest 70×30×90cm Ceramic, Gold leaf, Swarovski crystal, Oil painting 2016
(R) Think and more 57×48×6cm Ceramic, Silver leaf, Swarovski crystal, Oil painting 2015

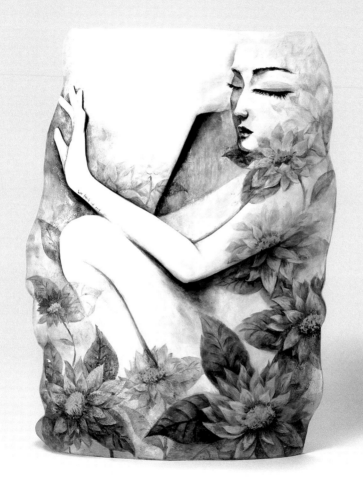

Rest (Back)

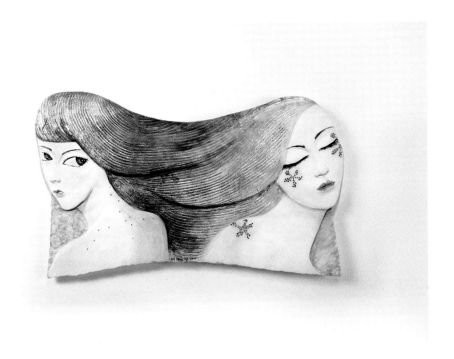

Time 86×51×7cm Ceramic, Gold & Silver & Copper leaf, Swarovski crystal, Glaze, Oil painting 2015

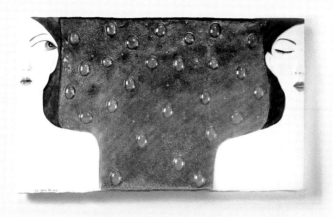

Black night 82×50×6cm Ceramic, Silver leaf, Swarovski crystal, Resin, Shimmer powders, Oil painting 2015

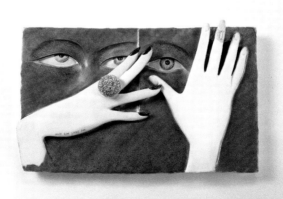

Vacation 48×30×6cm Ceramic, Swarovski crystal, Oil painting 2015

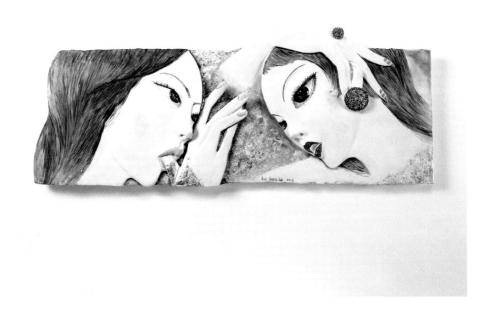

Dyeing 90×35×6cm Ceramic, Silver leaf, Swarovski crystal, Glaze, Oil painting 2015

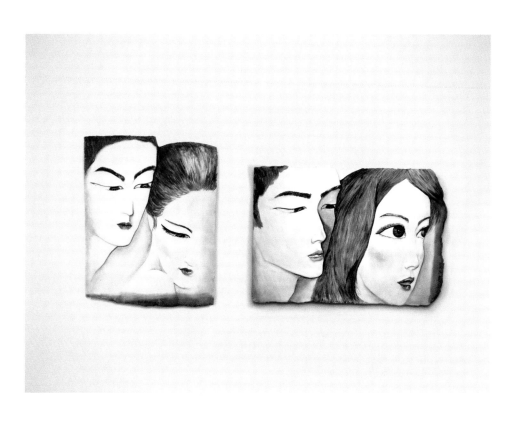

Looking at the same place 37×46×6, 52×37×5cm Ceramic, Oil painting 2015

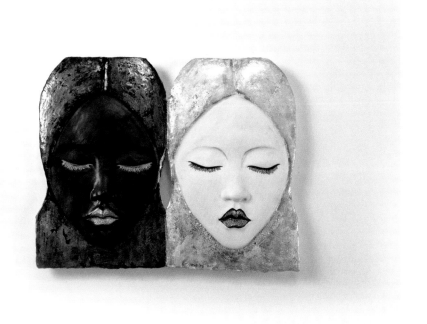

B & W 50×42×7cm Ceramic, Gold leaf, Silver leaf, Swarovski crystal, Oil painting 2016

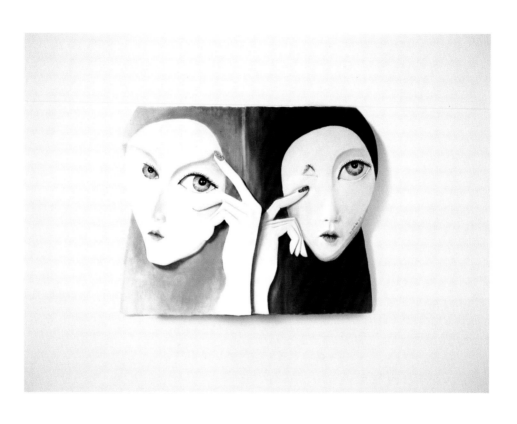

Day and Night 56×45×6cm Ceramic, Swarovski crystal, Oil painting 2015

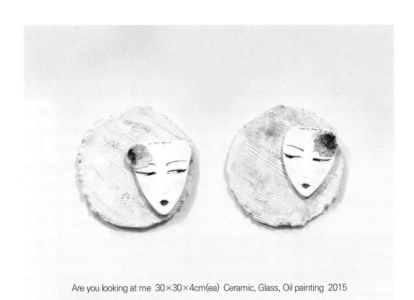

Are you looking at me 30×30×4cm(ea) Ceramic, Glass, Oil painting 2015

What are you looking at 30×30×4cm(ea) Ceramic, Gold leaf, Swarovski crystal, Oil painting 2015

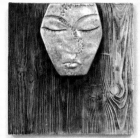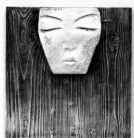

Perfume 30×30×6cm(ea) Ceramic, Gold leaf, Silver leaf, Swarovski crystal, Oil painting 2015

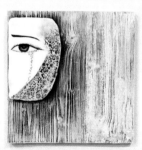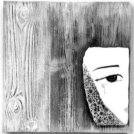

Tears 30×30×6cm(ea) Ceramic, Swarovski crystal, Oil painting 2015

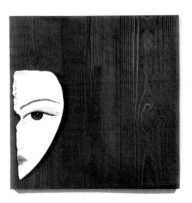 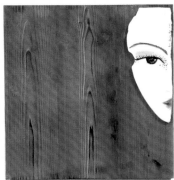

Open and Close 40×40×4cm(ea) Ceramic, Oil painting 2015

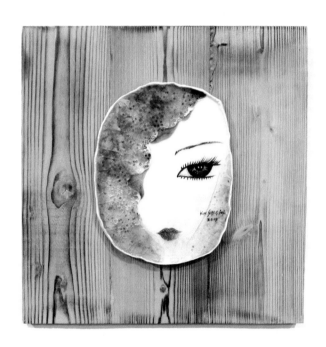

Love 40×40×4cm Ceramic, Resin, Shimmer powders, Glass, Oil painting, Wooden board 2015

마음에 다가오는 '진실'
– 김생화의 도자 예술

천귀훼이
미술학 박사, 비평가,
광저우미술대부교수, 화남미술관 관장

김생화는 2015년 한국과 중국에서 각각 제목 '너 자신을 봐봐'와 '널 봐봐' 두 번의 개인전을 열어, 오랜 세월 이국에서 살아온 자신 내면의 해석과 경험을 보여주었다. 작가는 "관람객은 한중 양국을 오가며 끊임없이 바뀌는 '나 자신'과 똑같이 변화하는 '또 다른 자신'을 작품 속에서 볼 수 있을 것"이라고 말했다. 전시에서는 타국에서 작품 활동을 하는 여성 작가로서의 어려움, 괴로움과 고통, 그가 인생의 도전에 직면하여 필요했던 엄청난 용기와 끈기, 경이로움이나 난처함, 방황이나 고민, 신중하거나 집착하는 등의 개인이 느꼈던 이국적인 체험을 볼 수 있다. 김생화의 최근 도예작품의 원천은 말로 형언할 수 없는 내면의 언어들이며, 이렇게 타국에서의 마음속 이야기를 털어놓은 최근작은 그의 자서전이라 할 만하다.

김생화의 작품을 해석해 보면, 그의 예술은 '고독한 개인'에서 탄생했다는 것을 알 수 있다. 그는 특정한 여성의 이미지를 앞뒤 양면에 서로 다른 형태로 표현하여, 실제로는 감춰져 있는 개인의 자전적 감정을 보여준다. 예를 들어 긍정과 부정, 남성과 여성, 진실과 위선, 평온과 왜곡, 갈등과 순응 등과 같은 개인 생활

경험을 이원론적 예술로 표현하여, 외국에서 생활하는 일종의 예술가로서의 존재감을 드러냈다. 바로 이런 개인과 현실 간의 타이트한 관계 (생존 경험에서의 충돌과 갈등 등의 존재감 포함)가 그의 예술을 '진실'로 만들었다.

예술가는 어떻게 마음속의 진실을 더 효과적으로 표현할 수 있을까? 거의 모든 예술가들이 이 문제에 어려움을 겪는다. 진실은 바로 현실이며, 예술가와 현실과의 관계는 항상 팽팽하고 모호하다. 진정한 현실은 종종 번잡한 현상 뒤에 숨어있어 파악하기 어렵다. 비록 예술은 허구지만, 예술가는 허구의 이야기, 줄거리, 인물을 만들 수 있다. 그러나 현실과의 밀접한 관계는 허구가 될 수 없으며, 이를 통해 진정성이 구현된다. 진정한 예술은 언제나 인간의 존재에서 배움을 얻고, 인류가 존재하는 실제 상황으로 표현되어야 한다. 그 기본적 차원을 따르지 않았다면, 예술도 그 본성을 잃게 된다. 이를 근거로 김생화의 도자 예술은 '인물 제작을 통해 존재에 대한 심오한 생각을 한다.', '알려지지 않은 미지의 내면을 드러내고 있다.'라고 할 수 있다. 내 생각으로 김생화의 예술을 이해하기 위해서는 단지 예술적 언어의 문제뿐만

아니라, 가마에서 완벽히 구워내어 그 위에 다양한 재료로 페인팅하고, 보석이나 자개 상감을 사용해 화려한 이미지를 표현했다는 것에 주목해야 하며, 그 배후의 정신세계를 이해해야 한다.

김생화의 작품 창작은 장기적이고 지속적이며, 심신과 체력을 많이 소모한다. 이 과정 중에 그는 예술 세계 안에서의 또 다른 자아를 깨닫고 느낀다. 그러나 그 동시에 현대의 도예가로서 단지 새로운 작품을 만드는 것이 쉽지 않을 뿐 아니라 육체적 정신적 헌신이 필요하며, 다른 문화의 만남과 충돌, 현실의 생존 감각과 내면적 갈등이 있다는 것에 대해 당혹함과 막막함을 느끼고 있다. 그래서 그는 최근 작품에서 다양한 인물들의 자세와 표정, 그리고 눈빛을 중점으로 여성스러움, 감상적인, 겁에 질린, 혹은 멍한 모습 등을 묘사하고, 그 위에 금박, 은박 등을 사용하여 소박한 중국 전통 도자와 다른 선명하고 화려한 독특한 예술 작품을 보여주었다.

김생화는 각양각색의 인물 표정을 만든다. 그는 형상의 실제 모양을 만들려고 의도하지 않고, 순간 자신의 의식 속에 있는 사람이 어떤 상태인지를 포착하는데 노력을 기울인다. 그것은 의식적인 환상, 혹은 기호적인 존재로, 그 순간의 경험과 환상을 '나' 안에 써넣는 것과 같다. 그는 모두가 '고독한 개인'으로 대체 할 수 없는 존재라고 말한다. 그가 느끼는 감정과 환상은 바로 자신의 생존에 대한 픽션이라 할 수 있다. 확신할 수 없는 자아, 복잡하고 유동적인 의식, 환상적인 심리 등을 어떻게 해야만 정확하고 효과적으로 표현할 수 있는지는 거의 모든 현대 예술의 난제이다.

김생화 도예의 서사적 표현을 보면서, 필자는 카프카 소설에 등장한 여러 가지 상황을 떠올렸다. 아마도 우리는 카프카 소설의 표현적 내용을 보고 현실을 읽어낼 수 없을지도 모르지만, 그가 표현한 현실은 우화나 상징이 아니라 스스로 경험한 현실(작가가 체험한 진실)일 것이다. 카프카의 마음속에서, 자신과 현실은 그야말로 원한이 깊이 사무친 원수만큼이나 혹독한 관계이며, 그 관계 중에 카프카가 어떤 고통을 겪었는지 상상할 수 있다. 나는 김생화의 도자 예술에서도 이처럼 마음에 다가오는 '진실'의 감정을 체험했다. (2016. 2. 1)

The "Truth" That Speaks to Your Heart
– Saenghwa Kim's Ceramic Art

Guohui Chen
Doctor of Fine Arts, Critics,
Associate Professor at GAFA,
Curator of South China Art Museum

Saenghwa Kim held solo exhibitions entitled "You look at yourself" and "Look at yourself" in Korea and China in 2015, respectively, to present her own interpretation of the inner essence and varied experiences from her long sojourn abroad. She remarked, "As I find 'myself' changing incessantly while traveling back and forth between Korea and China, viewers also witness 'another me' in my work, who also changes just as much." The exhibitions allow viewers to share in the exotic and multifarious experiences that Saenghwa Kim personally underwent, such as the difficulty, hardships, and pain that she felt as she led her career as a female artist abroad; exceptional courage and perseverance that she needed to tackle such challenges in life; and myriad emotions including wonder, embarrassment, uncertainty, concern, caution and obsession. Her latest ceramic works are derived from an inner language beyond description, which confess stories from deep in her heart, like an autobiography.

The interpretation of Saenghwa Kim's works show that her art originates from a "solitary individual." She reveals an individual's autobiographical emotions hidden within being, by juxtaposing images of a certain woman from the front and back in different manners. For example, she adopts dualistic art techniques to represent personal life and experiences, such as positivity vs. negativity, male vs. female, true vs. false, calm vs. distorted, and conflict vs. compliance, to expose her sense of being as an artist abroad. As such, this tense relationship between an individual and reality (including the presence of collisions and conflicts arising from her struggle for survival) has turned her art into the "truth."

How can artists approach the truth in their mind more effectively? Almost all artists face this challenge. The truth simply leads to reality and the relationship between artists and reality always remains taut and ambiguous. True reality eludes us because it is often camouflaged under complex phenomena. Though art is fictitious, artists create these fictitious stories, plots, and characters. Art's relationship with reality is far too intricate to be simply fictitious, which thereby establishes its authenticity. True art should always be inspired by what is learned from humans and expressed as real situations in which human beings exist. If art does not conform to this basic dimensional structure, it eventually loses touch with its true nature. Grounded in this idea, Saenghwa Kim's ceramic works can be defined as "pondering existence through the creation of figures," or "uncovering the inner world hidden in the unknown." From the author's perspective, the key to understanding Saenghwa Kim's art is

to recognize the language of art reflected in her works, more importantly to appreciate her works that are fired in kilns, painted in various materials, and inlaid with jewels to embody splendid images, and to delve into her mind as is projected onto her works.

Saenghwa Kim's way of creating art requires long and continuous efforts, exhausting the mind and the body. During this process, the artist realizes and feels another self in the world of art. At the same time, however, she feels perplexed and frustrated by the realization that, as a contemporary ceramist, it is difficult to create new works, in addition to the dedication of the mind and body, to experience the encounter and conflict with a different culture, and to process her internal conflict with her survival instincts based in reality. That is why Saenghwa Kim's latest works embody the artistic attributes of lucidity and splendor, in contrast with Chinese traditional ceramic art, which is mainly based on postures, facial and eye expressions, with the depiction of feminine, sentimental, frightened or blank features, in gold and silver mountings.

Saenghwa Kim creates a wide spectrum of facial expressions. She strives to instantly capture the state of a subject in her consciousness, without seeking to recreate the actual form of the subject. The figure is an illusion she creates out of her consciousness, or a signifier, and making facial expressions is akin to the act of registering experiences and illusions obtained within the moment onto the "self." She views all humans as irreplaceable "solitary individuals." The emotions and illusions that she senses can be described as a fictional narrative of her survival. A challenge that almost all types of contemporary art face is how to accurately and effectively express the undefinable self; the complex, flowing consciousness; and fantastic sentiments.

While watching the narrative expression of Saenghwa Kim's ceramic works, this author recalled the various situations represented in the novels of Franz Kafka. Although his novels are not works of realism, the reality that he expresses is neither allegorical nor symbolic, but rather represents Kafka's lived experience (the truth that he experienced himself), which allows readers to fathom the pain that he suffered from his relationship with reality. This author experienced the same emotion of the "truth" that pierces the viewers' hearts in Saenghwa Kim's ceramic works. (2016. 2. 1)

逼近内心的"真实"：
金生花的陶瓷艺术

陈国辉
美术学博士,批评家,
广州美术学院副教授,华南美术馆馆长

2015年，金生花分别在韩国和中国举办个展，主题是"你看你自己"，"看看你自己"，侧重的是个体长期在异国生活多年的自我内心的剖析与生存体验的表达。以艺术家的心灵独白为凭，"观者会在作品中看到奔波于中韩两国，不断变换的'我自己'以及同样变化着的'你自己'。"可以想见，一个弱女子在异国他乡从事艺术创作，所遭遇到的种种困难、辛酸与苦楚，她需要巨大的勇气和毅力去面对生活的挑战——个体内心的种种异国体验与感受，惊奇或困顿，彷徨或苦闷，深沉或执着，所有这些内心无法言说的话语都化作为金生花近期陶瓷艺术创作的源泉，诉说着她在异国他乡的内心故事，甚至可以说，她的陶瓷艺术近作便是她的自传。

我们来解读金生花的陶瓷艺术便有更多的发现——她的艺术诞生于"孤独的个人"，塑绘了某些个体女性形象的正反面两种截然不同的形态，实质上隐含着个体自传式情感表达的影子。毫无疑问，她通过个体生活经验的两面性的艺术表达，譬如正与反、男与女、真实与虚伪、宁静与乖张、抵触与从众，等等，道出艺术家生活在异国他乡的某种存在感——正是

这种个体与现实之间的紧张关系（包括生存经历中的冲突与矛盾等的存在感），才使她的艺术变得"真实"起来。

艺术家应该如何更有效地接近内心的真实呢？几乎所有的艺术家都在这个问题上遇到了困难。真实的就是现实的，而一个艺术家与现实的关系总是紧张而暧昧的。真正的现实往往隐藏在繁杂的现象背后，难以把握。虽说，艺术可以有虚构的成分，艺术家可以虚构故事，情节，人物，他与现实的紧张关系却是不能虚构的，真实性也由此而贯彻出来。毕竟，真正的艺术永远是人的存在学，它必须表现人类存在的真实境况，离开了存在作为它的基本维度，艺术也就离开了它的本性。以此为据，金生花的陶瓷艺术是"通过塑绘出的人物对存在进行深思"，"揭示存在的不为人知的内心世界"，我认为，解读金生花的艺术，不仅仅是艺术语言的问题，更重要的是透过其烧制，加入多种材料彩绘以及宝石镶嵌的光鲜形象，探知其背后的精神世界。

就金生花而言，艺术创作是一种长期的、执着的，并且非常消耗身心和体力的发现，在这种发现的过程当中，她领悟和感受到了艺术世

界中的另一个自我；但与此同时，她也困惑和迷茫起来，作为当代陶艺家，不仅作品的诞生是多么的不容易，不光是其心智和体能的付出，还有异域文化的交汇与冲突，现实生存感受与内心的矛盾。……因此，在她的近期作品当中，各种各样的人物神态和表情乃至眼神成为重点刻绘的对象，或妩媚，或伤感，或惊恐，或木然，在金箔、银箔等彩绘之下，一反中国传统陶艺柴烧的质朴风格，呈现出光鲜、香艳的艺术特质。恰恰在这种表层具有装饰意味的视觉形象之下，不难察觉出艺术家的自我的危机，不仅来自于我与世界的疏离，更来自于我与自我的疏离——当我成了自己的旁观者，这是一种更为内在的孤独。如何找回生命的意义，如何重释人与世界的关系，这是每一个现代人都要直面的难题。是无奈，焦虑，还是孤绝地反抗？这不仅是个体的选择，也是现代艺术的选择。金生花塑造的各式各样的人体头像表情，她无意于具象的真实形塑，而是竭力去捕捉此刻进入我的意识之中的人像是怎样一种状态——它更像是意识的幻影，或者说是一个符号性的存在，书写"我"在此刻的体验与幻象。她讲述的都是一个"孤独的个人"那无法代替

的此在，她的感觉与幻象，说出正是她对生存的迷思——一个无法确证的自我，一种复杂而流动的意识，一种幻梦般的心理，如何才能得到准确、有效的表达，这几乎是所有现代艺术的难度。

由金生花陶瓷艺术的叙事表达，笔者不由得想起卡夫卡小说里的种种境遇：也许我们在卡夫卡小说的外表读不到多少现实的特征，但他所表达的现实不是一个寓言，一个象征，而是一个真正的现实——作家所体验到的真实——在卡夫卡那里，他与现实的关系真可谓是到了不共戴天的严厉程度，在这种关系中，可以想见卡夫卡的心灵要遭遇怎样的痛苦——我在金生花的陶瓷艺术中也同样体验到了如此逼近内心"真实"的情感。

"You look at yourself" Solo Exhibition 2015. 9. 2 – 9. 8 (Korea)

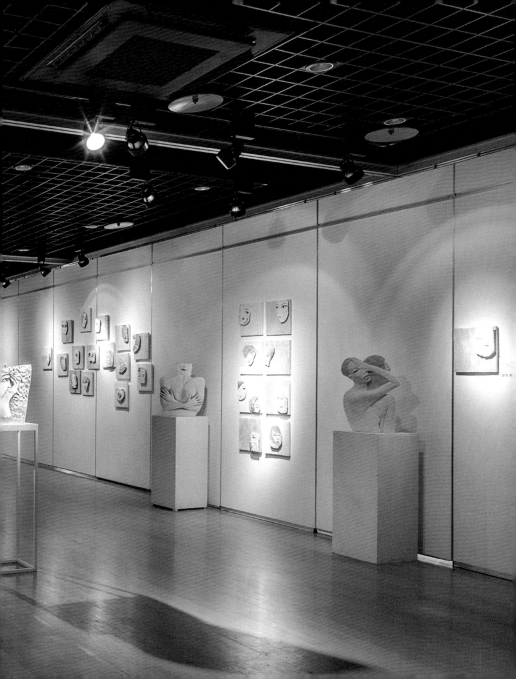

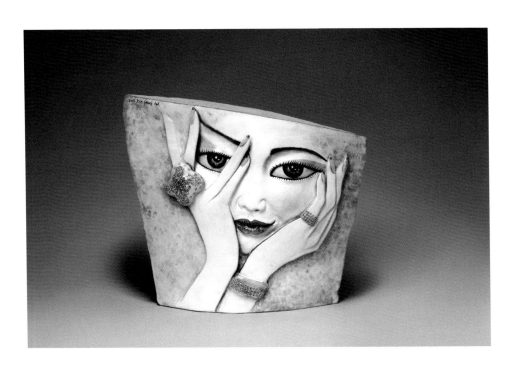

Don't want to see & Want to see (Back)

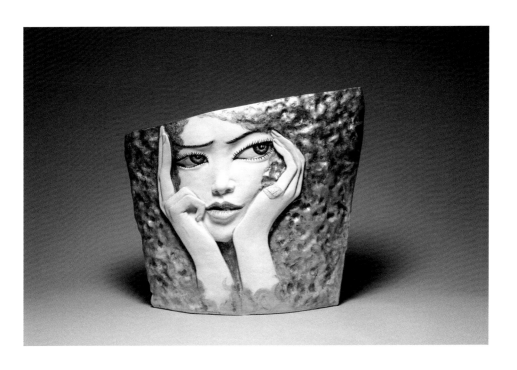

Don't want to see & Want to see 90×35×6cm Ceramic, Gold leaf, Lacquer, Oil painting 2015

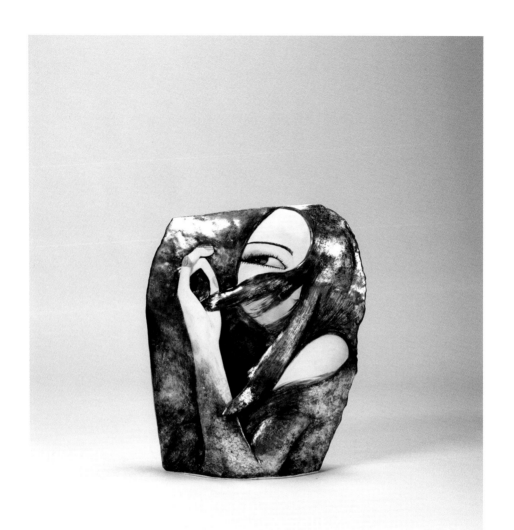

Smell (Back)

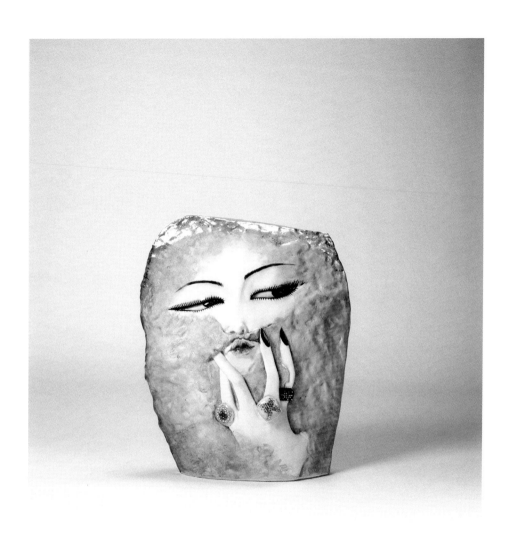

Smell 43×22×52cm Ceramic, Silver leaf, Swarovski crystal, Glaze, Oil painting 2015

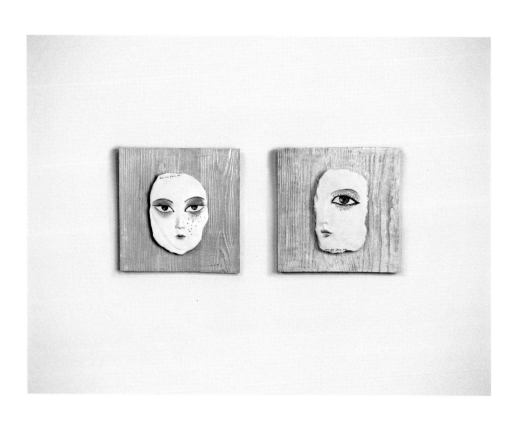

A 100-day diary-'Dark Circle' series 30×30×5cm(ea) Ceramic, Wooden board 2015

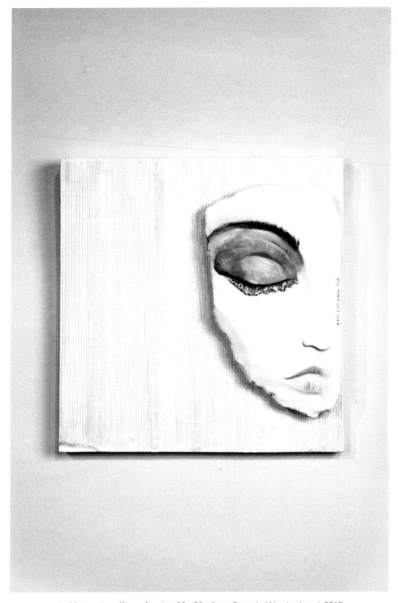

A 100-day diary-'Dream' series 30×30×6cm Ceramic, Wooden board 2015

 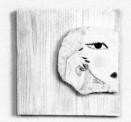 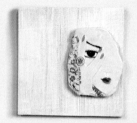

A 100-day diary-'Dress up' series 30×30×5cm(ea) Ceramic, Oil painting, Wooden board 2015

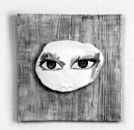 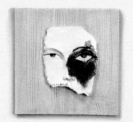 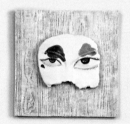

A 100-day diary-'Eye shadow' series 30×30×5cm(ea) Ceramic, Oil painting, Wooden board 2015

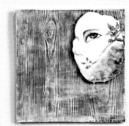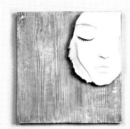

A 100-day diary-'Seasons' Series 30×30×6cm(ea) Ceramic, Oil painting, Wooden board 2015

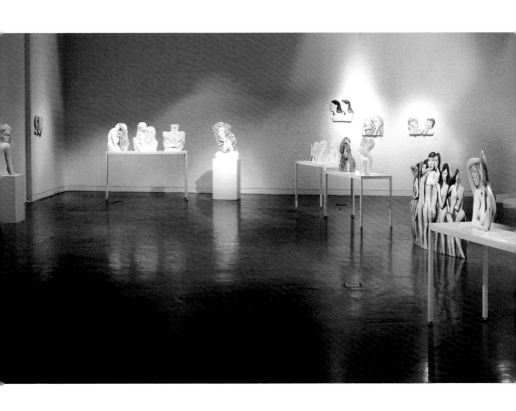

"Can you see your back?" Solo Exhibition 2013. 8. 28 – 9. 3 (Korea)

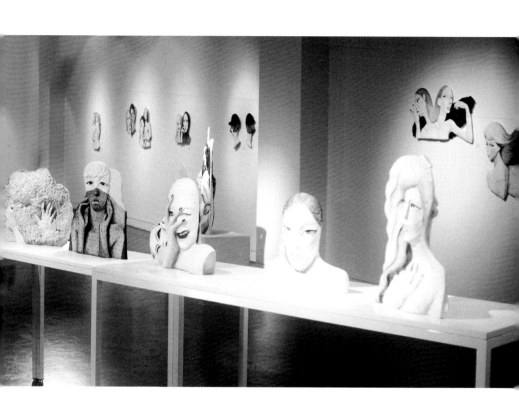

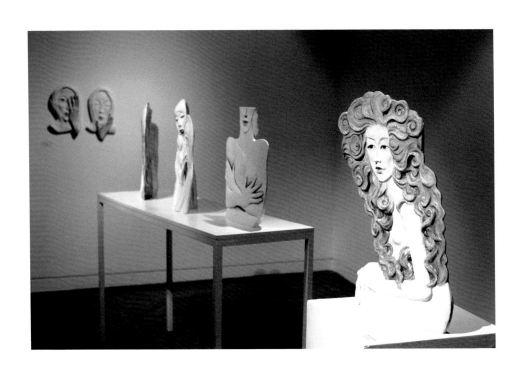

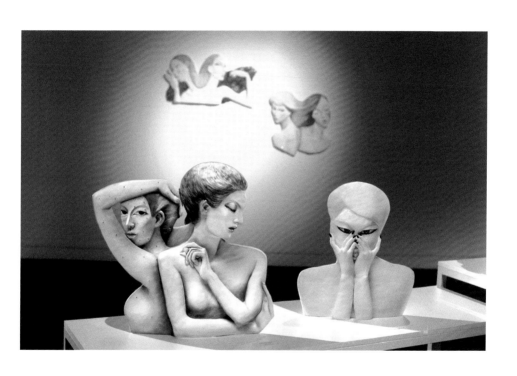

"Can you see your back?" Solo Exhibition 2013

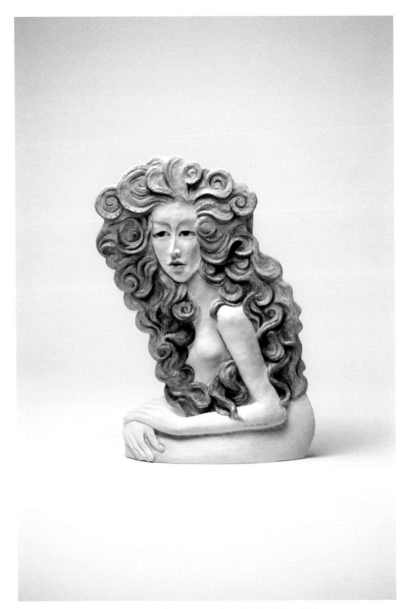

Listening & Rest 50×15×75cm Ceramic, Oil painting 2013

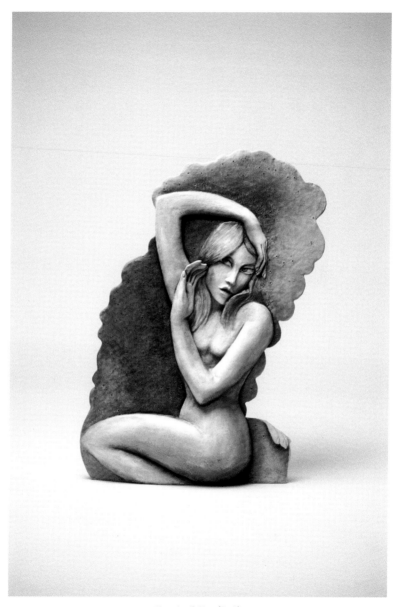

Listening & Rest (Back)

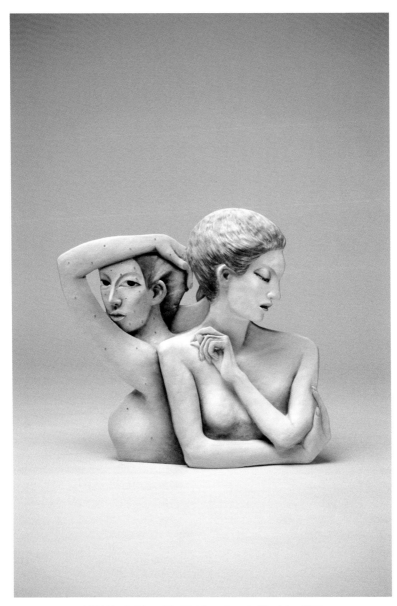

남&남 Men & Others 58×15×56cm Ceramic, Oil painting 2013

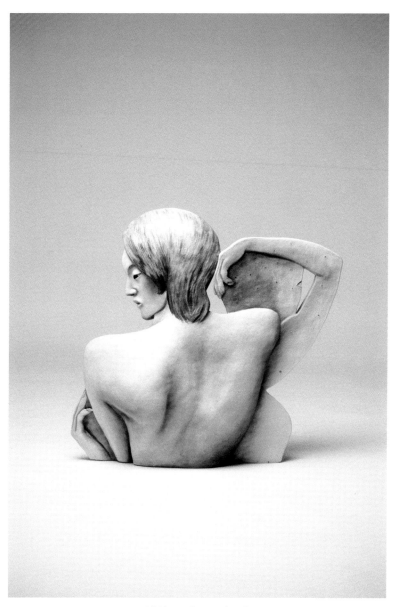

남&남 Men & Others (Back)

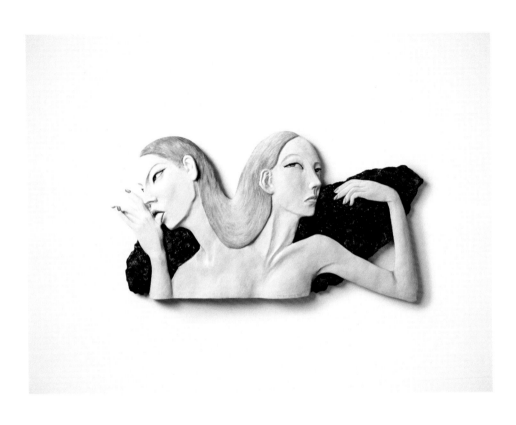

Perfume 89×45×2cm Ceramic, Oil painting 2013

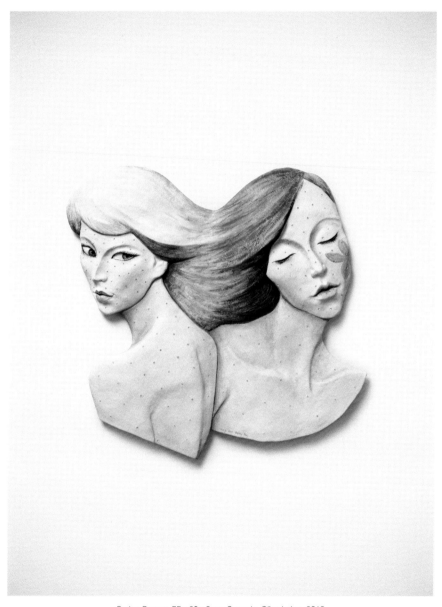

Spring Breeze 55×60×3cm Ceramic, Oil painting 2013

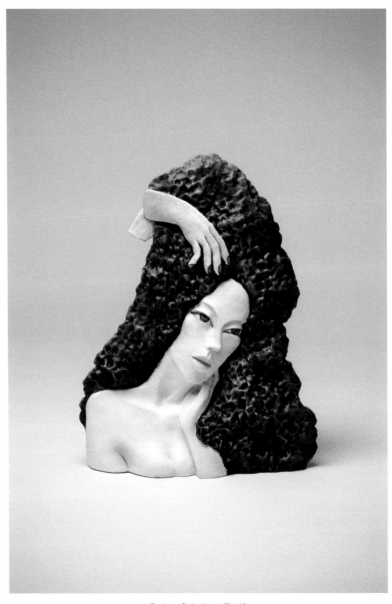

Envious & Jealousy (Back)

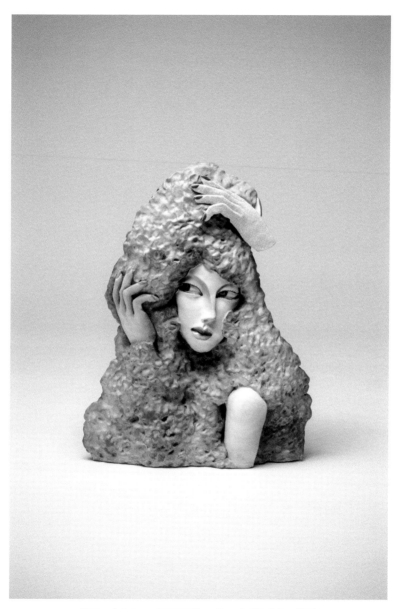

Envious & Jealousy 44×12×56cm Ceramic, Oil painting 2013

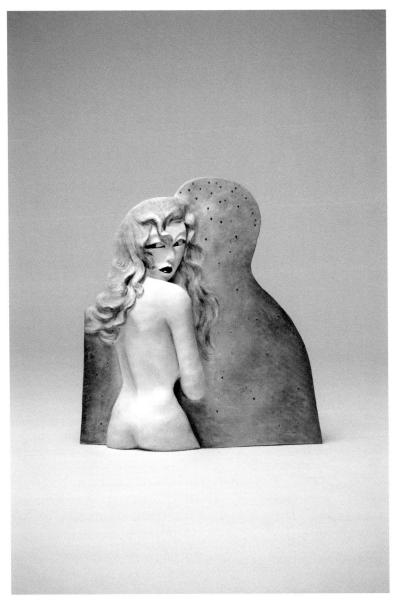

Hear & Shout 47×12×42cm Ceramic, Oil painting 2013

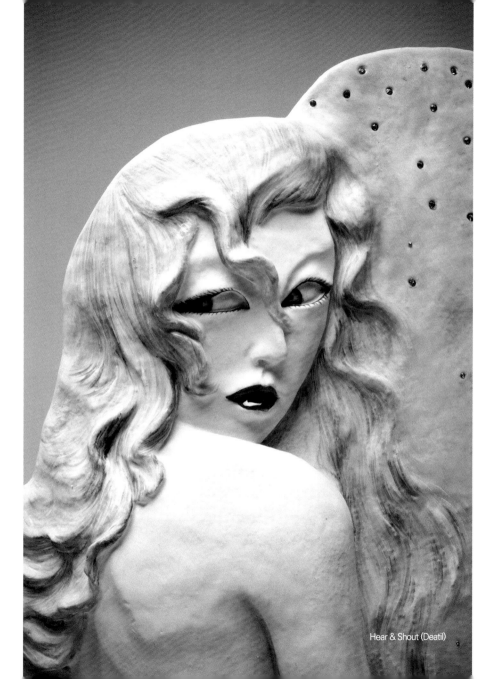

Hear & Shout (Deatil)

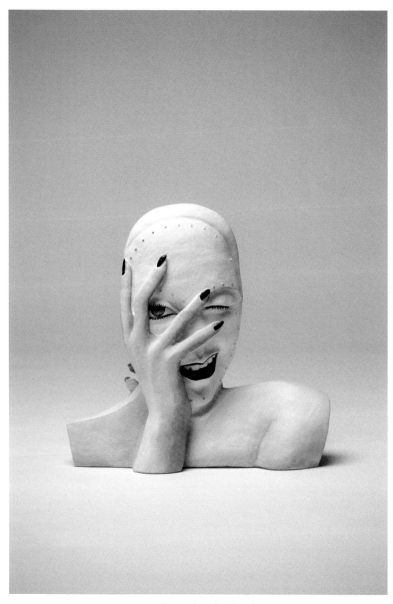

Mask & Mask 假面&假免 (Back)

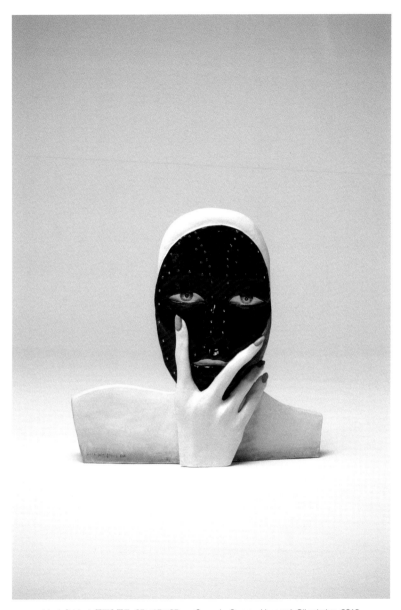

Mask & Mask 假面&假兔 35×15×35cm Ceramic, Swarovski crystal, Oil painting 2013

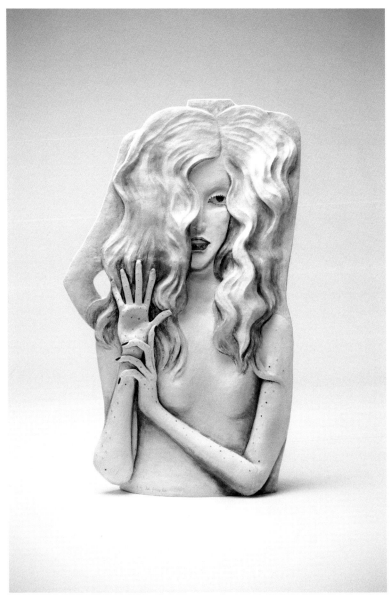

手&纸 58×16×95cm Ceramic, Oil painting 2013

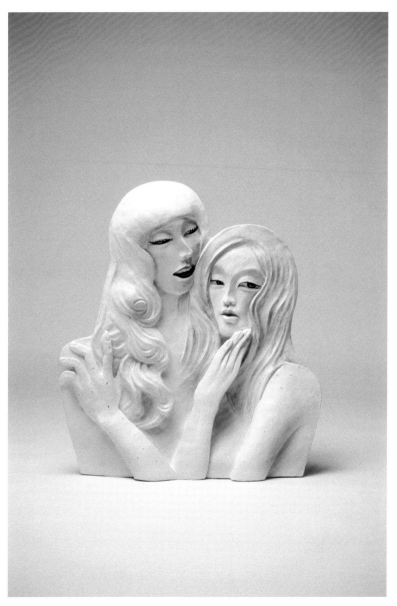

Tear & Ecstasy 53×14×63cm Ceramic, Oil painting 2013

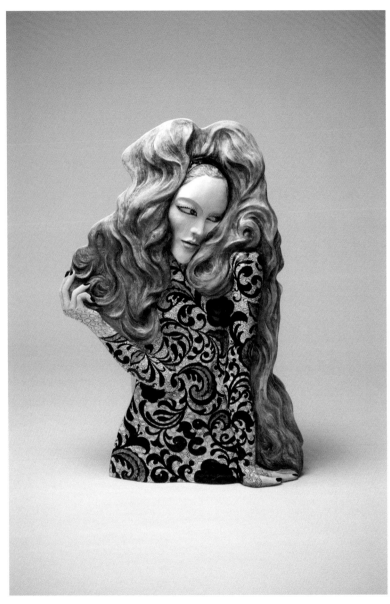

Shy & Sweetness 52×18×85cm Ceramic, Oil painting 2013

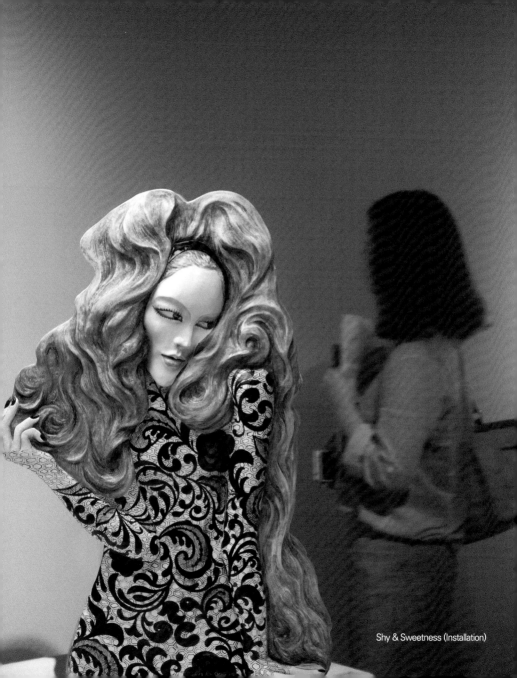

Shy & Sweetness (Installation)

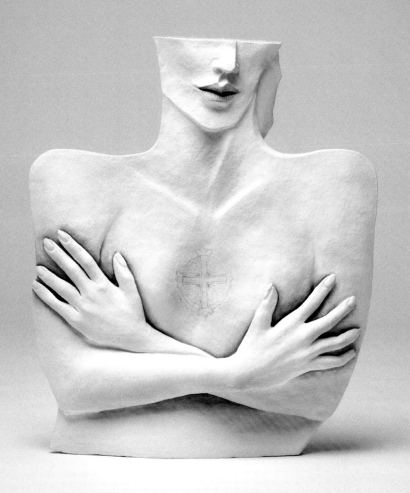

신앙 그리고 번민 Faith & Anguish 46×13×53cm Ceramic, Oil painting 2013

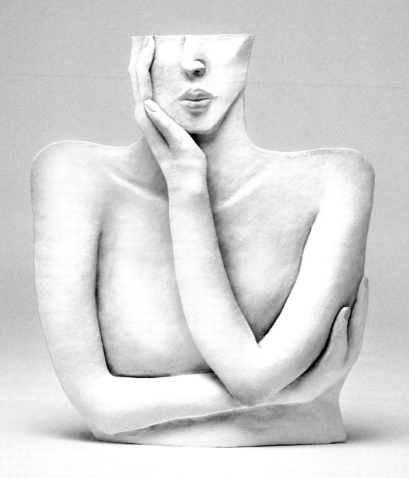

신앙 그리고 번민 Faith & Anguish (Back)

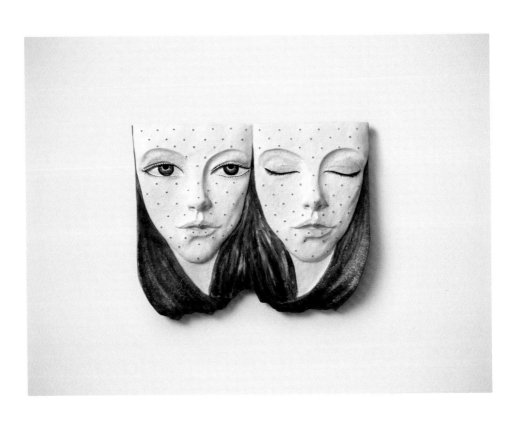

Close eyes 35×27×2cm Ceramic, Oil painting 2013

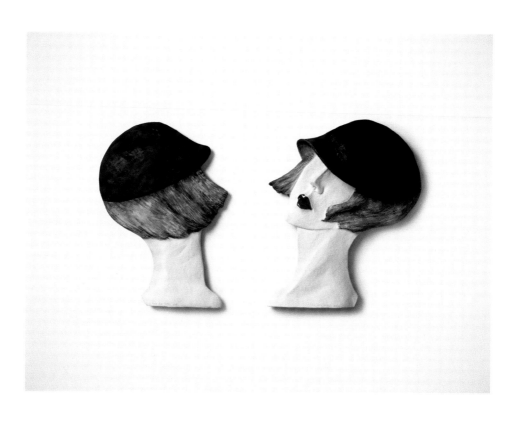

Hide 27×43×5cm(ea) Ceramic, Oil painting 2013

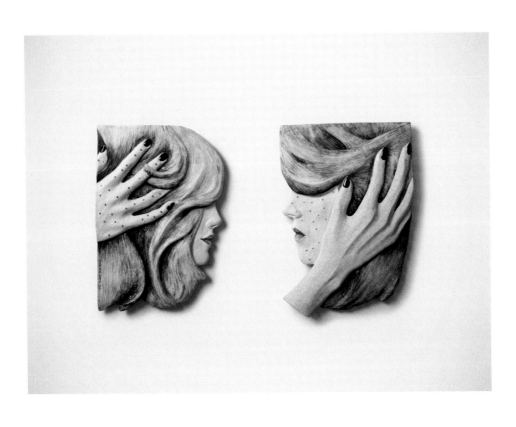

Hide-and-seek 28×36×3cm(ea) Ceramic, Oil painting 2013

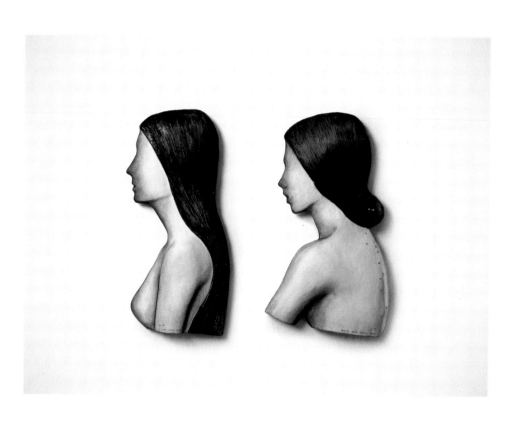

Tie 45×38×2cm Ceramic, Oil painting 2013

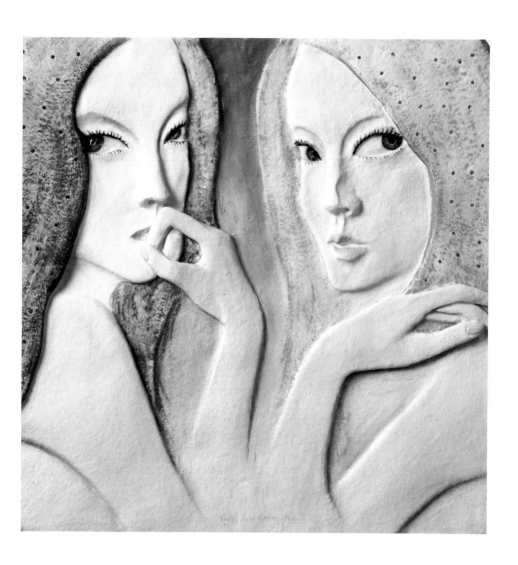

감정 그리고 냉정 Emotion and calmness 43×36×3cm Ceramic, Oil painting 2013

"Bleach" Solo Exhibition 2016. 3. 27 – 4. 26 (China)

숲속의 교향악
Symphony of the Nature
林中交響樂

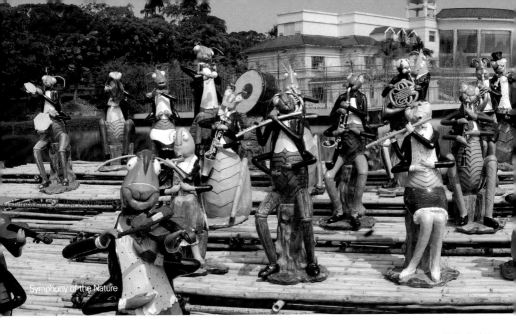

Symphony of the Nature

숲속의 교향악

치우따이룬
1506 창의그룹 회장

2009년 중국포산도자축제 기간 동안 한국 작가 김생화의 개인전 〈숲속의 교향악〉이 도예문화공원 수중 무대에 설치되었다.

그의 예술 생명은 부지런히 지치지 않고 새로운 예술 창작을 추구하는데 있다. 짧은 1년여 시간에 100여 개의 훌륭한 도자작품을 창작했다. 그는 사람들에게 시각적 감동과 생명의 생동감을 보여주었으며, 비로소 대중에게 사회 속의 생명 개체에 대한 의미를 되돌아보게 하였다. 김생화는 작품을 통해 실물과 같은 생동감을 묘사함으로서, 인간의 본성에 대한 날카로운 관찰력과 생명에 대한 심오한 철학적 사고를 형상화하고 있다.

그는 국제도자문화공원과 〈숲속의 교향악〉이 도예계의 새로운 신호탄이 될 것이라 말한다. 김생화의 개인전은 포산의 전통도예문화가 현대화와 국제화에 발맞춰 어떻게 소통하고 충돌하고 있는지를 보여주는 대표적 전시회가 될 것이다. (2009. 10. 18 기축년 가을 1506 창의성에서)

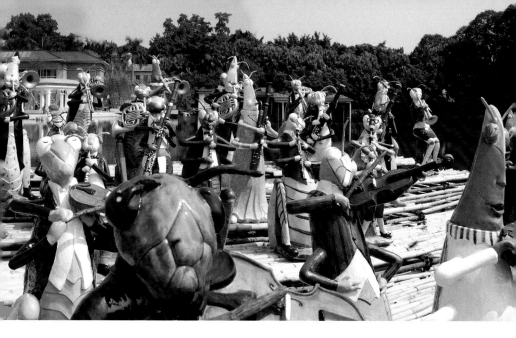

Symphony of the Nature

Dailun Qiu
1506 Chairman of
Creative company

During the 2009 China Foshan Ceramics Festival, Korean artist Saenghwa Kim's solo exhibition "Symphony of the Nature" was held on the floating platforms at Foshan Shiwan Park.

Saenghwa Kim's artistic life can be summarized as an industrious, tireless pursuit of new artistic creation. The artist produced more than 100 pieces of brilliant ceramic works within just a year. She imparted to the viewers a visual impact and sense of vivacity, which led them to reflect on the meaning of an individual living being within society. Through the realistic rendering of vitality in her works, Saenghwa Kim embodies her poignant observation on human nature and profound philosophical thoughts on life.

The artist notes that the Foshan Shiwan Park and "Symphony of the Nature" will serve as a new catalyst for the ceramic art circle. Saenghwa Kim's solo exhibition will demonstrate how the traditional ceramic culture in Foshan communicates and collides with modernization and globalization. (2009. 10. 18 1506 CreativeCity)

林中交响音乐会

邱代伦
1506创意园董事长

适逢2009中国（佛山）陶瓷节举办暨南风古灶国际陶文化公园建设启动之际，韩国艺术家金生花的个人陶艺作品展<林中交响音乐会>，悠然踏上了陶文化公园的水上舞台。

金生花在其艺术生命里，一直孜孜不倦地追求艺术创新。她在短短一年多的时间创作了一百多件高质量的陶艺作品。这给人以视觉的震撼，呈现其生命的质感，并向大众传达她对社会及生命个体的深刻感悟。

金生花其作品是对自然惟妙惟肖的描绘，是对人性入木三分的刻画，是对生命深邃悠远的哲思。她亦言"国际陶文化公园和'林中交响音乐会'在陶艺界都是一种新事物。"金生花的个展代表了佛山传统陶文化与当代性、国际性的一种对话和碰撞。
（己丑年秋 于1506创意城）

특별한 일상

나는 한국에서 십여 년이 넘는 시간을 흙과 함께 했다. 반복되는 평범한 일상에서 벗어나고자 중국 유학을 선택했고, 학교 졸업 후 지방의 도자 산지로 내려왔다.

아침잠을 깨우는 새의 지저귐, 어둠 속에서 들리는 풀벌레 소리, 별 아래 하늘을 날아다니는 박쥐, 몇 백 년 된 집 지붕 위에서 들리는 쥐를 쫓는 고양이의 발자국 소리, 근육통 때문에 붙인 파스와 흙 곰팡이 냄새가 진동하는 작업장, 숨쉬기조차 힘들고 길었던 여름… 그렇게 1000일 동안의 특별한 일상을 경험했다. 그 일상 중에 난생처음 큰 도자 작품을 완성해 제작의 기쁨을 느끼기도 했고, 한국사람 하나 없는 이곳에서 평생 흙을 만지고 살았던 낯선 타국 친구에게 용기와 희망을 얻기도 했다.

작업장을 구하고 처음 얼마 동안 이전 작품을 답습하고 있다는 생각이 들었고, 항상 누군가가 같은 작품을 제작하고 있는 나의 모습을 비웃는 것처럼 느껴졌었다. 어느 날 작업을 마치고 돌아와 뜰에 앉아 달을 보며 낙담하고 있었는데, 풀벌레의 울음소리가 들렸다. 그 소리가 마치 나에게 위안의 말을 건네는 듯 했고, 점점 작은 소리들이 모여 거대한 교향악을 이루는 것 같았다. 밤마다 상상했던 교향악은 반년 동안 풀벌레가 악기를 연주하는 모습으로 의인화하여 모델링했고, 다시 반년이 넘는 시간 동안 여러 가지 제작기법을 시도해 작품을 실제 사람의 크기로 제작할 수 있었다. 특별한 일상에서 온 영감을 바탕으로, 2년 동안의 제작 기간을 거쳐 총 130여 개의 '숲속의 교향악'을 완성했다. 이 작품을 보는 이들이 상상 속의 음악을 듣고 지친 영혼을 치유할 수 있길 바란다. (2009. 8 중국 광둥성 포산 스완에서)

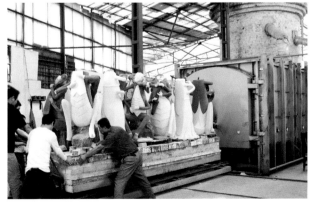

Unusual Routine

I spent more than a decade working with soil in Korea. To escape from my repetitive, mundane daily life, I chose to study abroad in China and settled in a provincial ceramic-producing district after graduating from school. The birdsong that woke me up each morning; the sound of bugs roaming through the grass in the darkness; bats flying across the starry sky; a cat's footsteps chasing a rat on the roof of the centuries-old house; a workshop that reeks of pain relief patches plastered for muscle aches, and musty earth; and a long, long summer that made it hard to even breathe...... Such were the thousand days of unusual routines I experienced. Amidst these routines, I felt the joy of creation after completing a large-scale ceramic work for the first time in my life and received courage and hope from a friend in an unfamiliar country, who had also experienced a lifetime of working with soil.

For a while at the beginning, I felt that I was merely following the same old path of my previous works. I also felt as if someone was laughing at me as I meekly ran the rat race of producing the same kind of works. One day, I was sitting in the front yard, frustrated after finishing off a day, when I heard the sound of bugs in the grass. It sounded like words of solace to me at the time and felt as if the tiny sounds were coming together to form an enormous symphony. Over half a year, the symphony that I had imagined every night was modeled into the personified insect figures playing musical instruments, then, for another half a year, into life-size figures made using a variety of techniques. The inspiration of unusual routines and two years of endeavors were embodied into a total of 130 works. I hope that weary souls of the viewers will be healed by this exhibition, "Symphony of the Nature". (2009.8 In Foshan, China, Saenghwa Kim)

特别的日常

在韩国我已从事陶艺10年，为了摆脱一成不变的生活选择中国留学，毕业之后来到陶瓷产区。清晨窗外叽叽喳喳的鸟叫声，夜里的虫鸣声，几百年历史的屋顶上猫追老鼠的脚步声，蝙蝠在有星星的夜空中飞来飞去，工作室经常出现的膏药味和泥土发霉的气味，炎热得令人呼吸困难的夏天，这一切组成了我1000天特别而又寻常的生活。在这样的日常生活中，我第一次感到做大型陶艺作品带给我的兴奋，在这个几乎见不到韩国人的地方，陶艺行业的朋友给了我继续前行的勇气和信心。

初期一段时间，我感觉自己正在沿袭以前的作品，总觉得有人在嘲笑我正在创作同一部作品的样子。有一天在天井看月亮，听到草虫叫声，其声音仿佛在说着维安的话，小声渐渐聚集起来，似乎形成了一首巨大的交响乐。每晚想象交响乐的场景，经过半年时间创作草稿，以乐器演奏的拟人化的草虫，再经历半年时间，才能将每部作品放大成真人大小。通过特别的日常中的灵感和两年时间的努力，完成了130多件的'林中交响乐'作品，希望作品治愈观众们的灵魂。(2009年8月 在广东佛山)

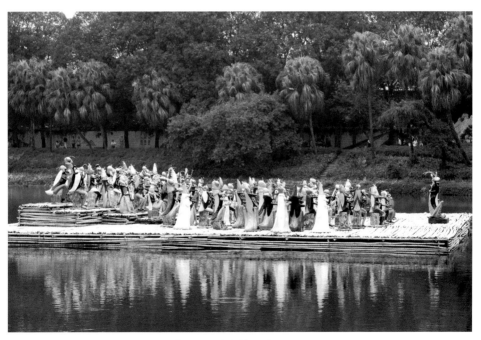

Symphony of the Nature Side View

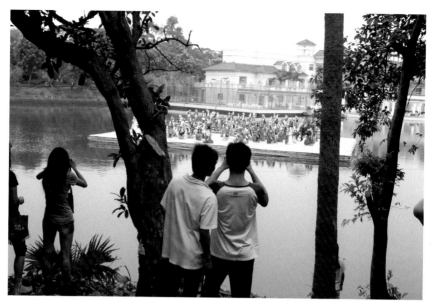

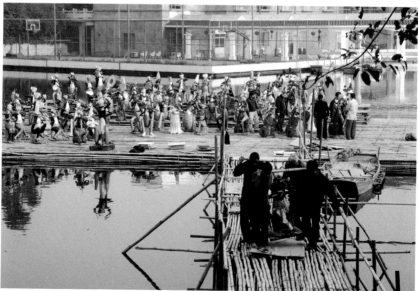

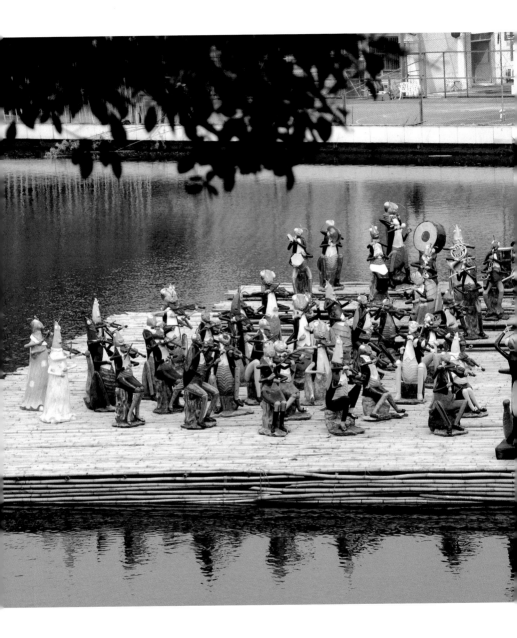

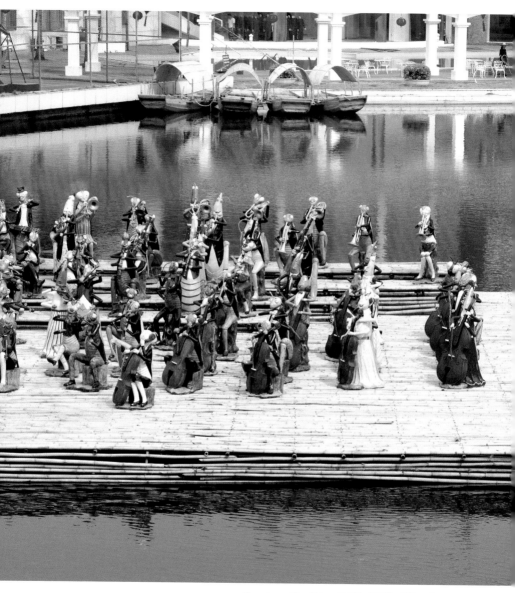

Symphony of the Nature 15000×20000×300cm Ceramics 2009

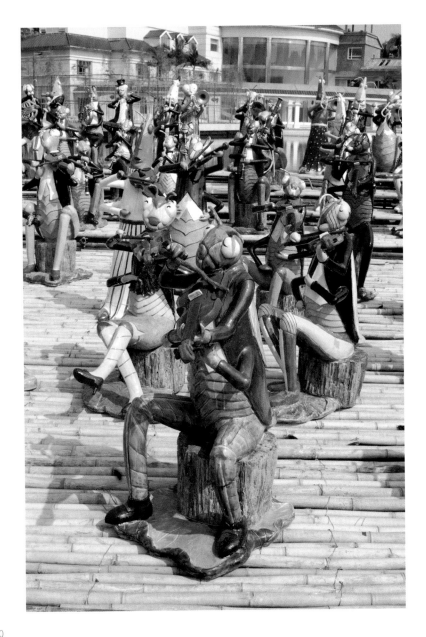

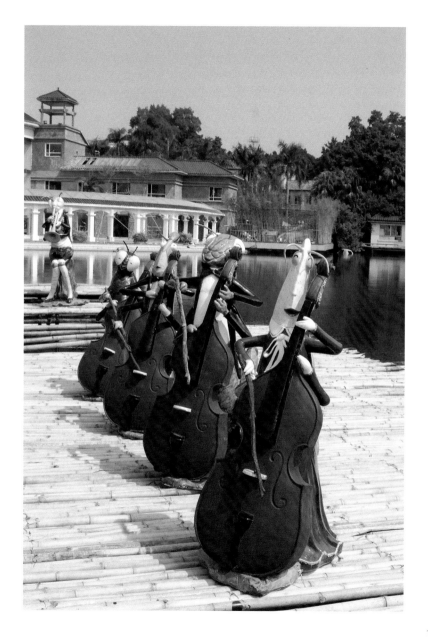

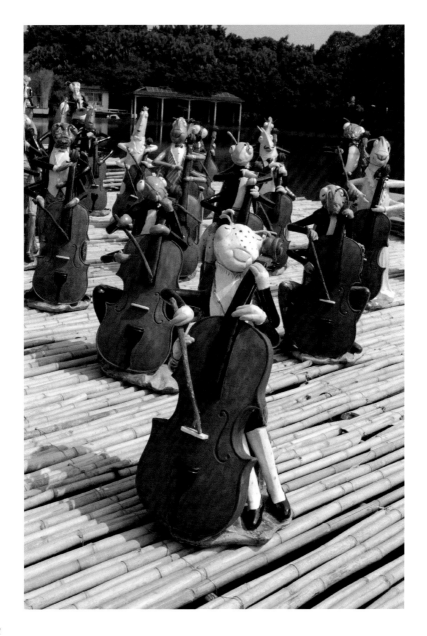

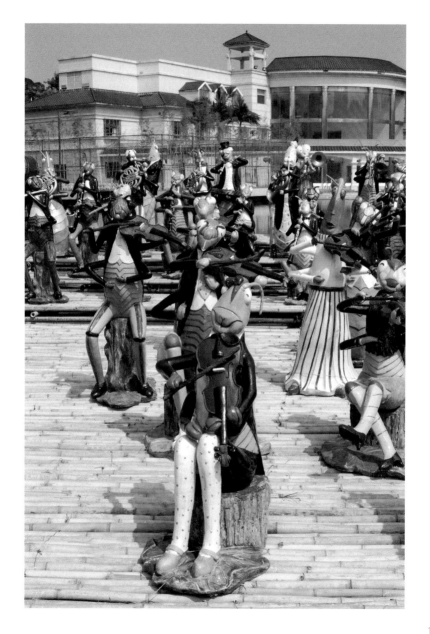

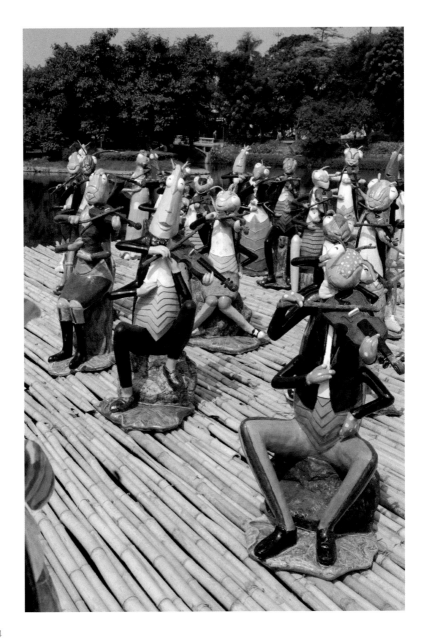

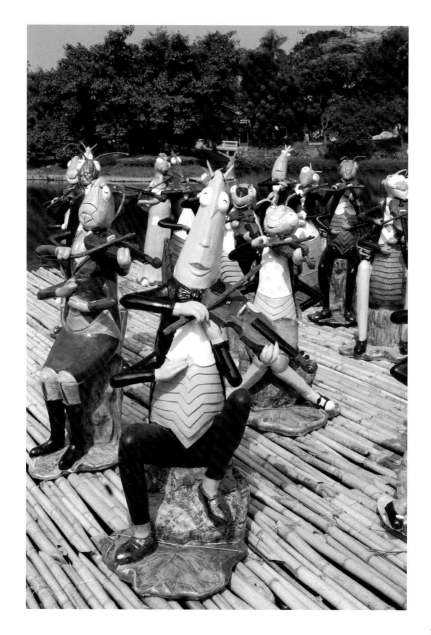

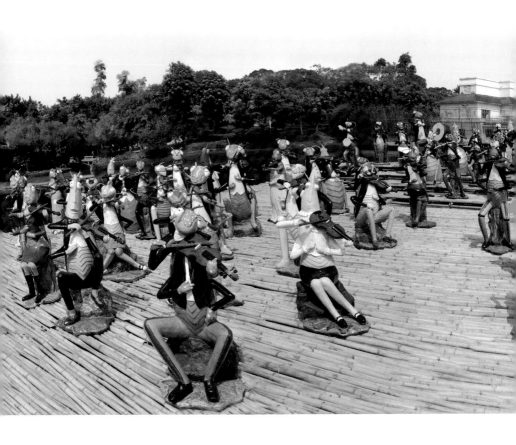

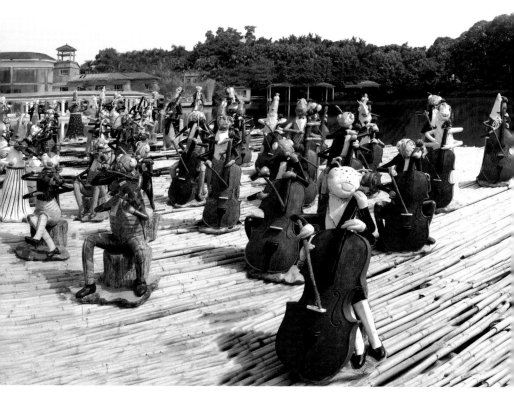

"Symphony of the Nature" China(Foshan) International Ceramics Festival Invitation Solo Exhibition 2009. 10. 1 – 2010. 1. 16

커뮤니티
Community
群

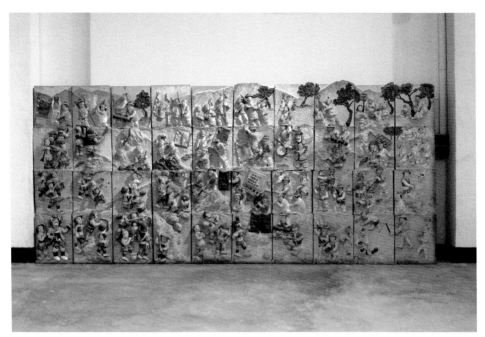

Battle of Haengju 520×50×230cm Ceramics 2007

　나는 타인의 관계에 대해 사고하며, 사람과 사
람, 혹은 사람과 사회와 관계, 즉 커뮤니티를 주
제로 도자 군체 인물 조각을 제작했다. 소위 군
체 인물 조각이란, 두 개 이상의 인물 조형으로
구성되며, 인물간의 연관성이나 이야기가 있거
나, 인물 조합의 형태를 가진 조각을 말한다. 인
물들 간의 관계를 구성하고 특별한 장면이나 독
특한 분위기를 연출하여, 관객들이 자신의 경험
이나 실제의 모습을 상상하며 친밀감을 느낄 수
있도록 했다. (2006. 6 베이징에서 김생화)

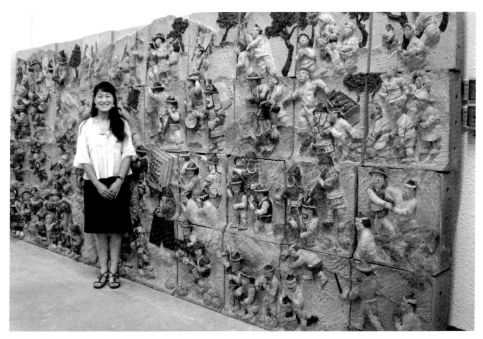

Battle of Haengju and the Artist

The sculptured figure group means a sculpture consisting of two or more figure, with certain episode or combination relations among figures. This kind of sculpture relies more in the grouping of figures to show a special scenario or produce a kind of air to express the final target.

The products themed by daily life expressed the artist's self-experience and the scenarios of real life, moving the audience to feel warm. (June 2006, Tsinghua University, Beijing, Saeng Hwa Kim)

本人思考与他人的关系, 以人与人或人与社会之间的关系, 即以共同体为主题, 制作了陶瓷群体人物雕塑。所谓群体人物雕塑, 是由两个以上的人物形象构成的, 人物之间有一定的关系的、带有一定情节性或组合关系的雕塑, 这种雕塑更多的是依靠人物之间的组合关系。构成某种特殊的场景或营造出独特的气氛, 观众们想象自己的经验或真实的样子, 让人感到亲切。(2006. 6 在清华大学, 金生花)

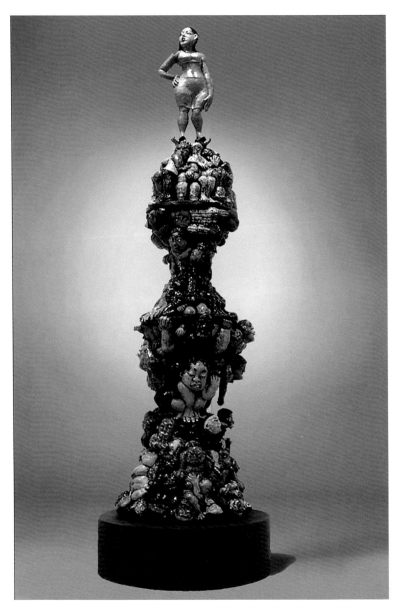

Trophy awarded to a man who loves a woman　100×100×360cm　Ceramics　2003

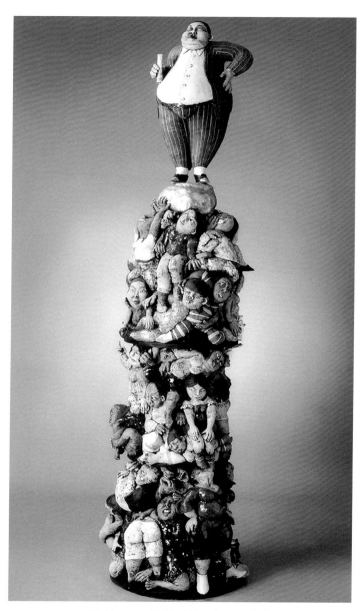

What is money 80×80×320cm Ceramics 2002

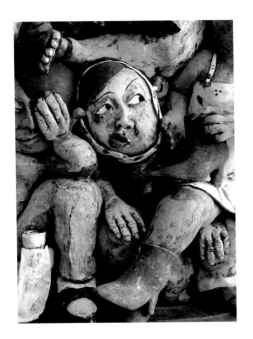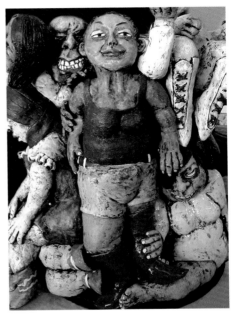

What is money (Detail)

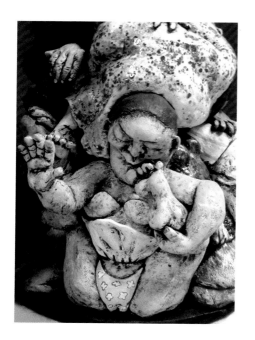
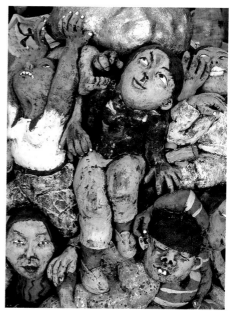

What is money (Detail)

Korean students in Beijing 500×120×40cm Ceramics 2005

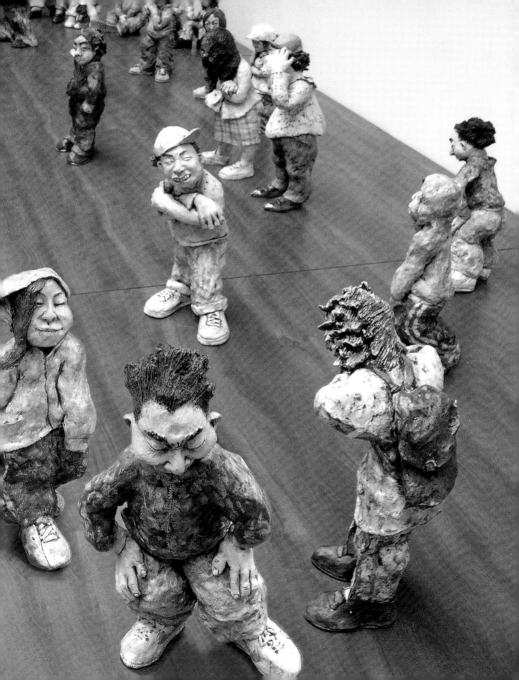

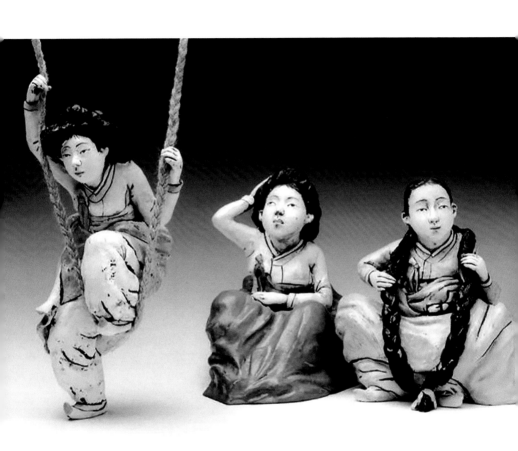

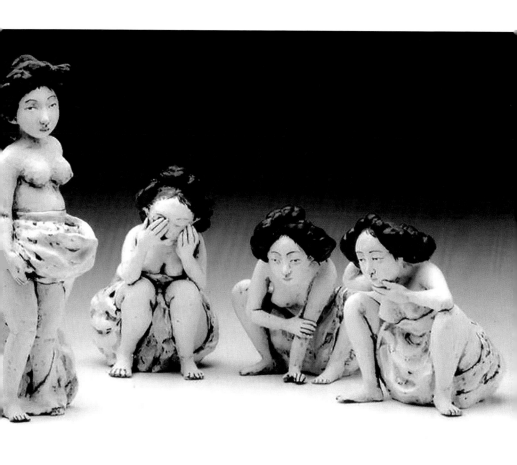

The Tano view 110×20×33cm Ceramics 2002

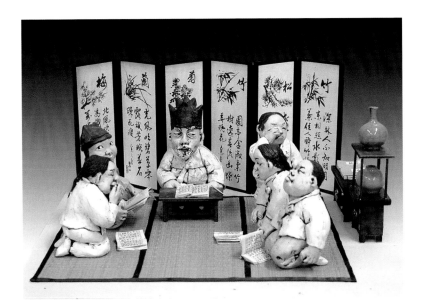

History of books–Village School 50×40×15cm Ceramics, Mixed material 2003

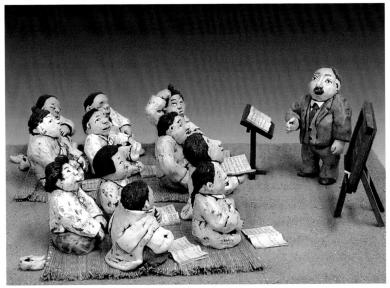

History of books – Classrooms of the '50s 50×40×15cm Ceramics, Mixed material 2003

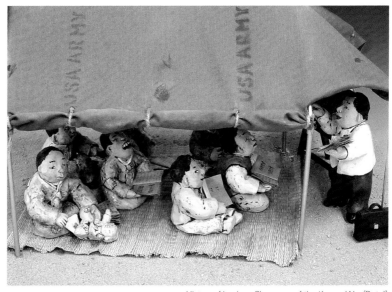

History of books − Classroom of the Korean War (Detail)

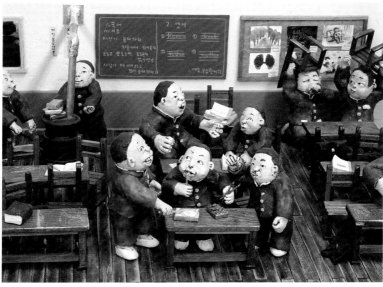

History of books − Classrooms of the '70s 50×40×15cm Ceramics, Mixed material 2003

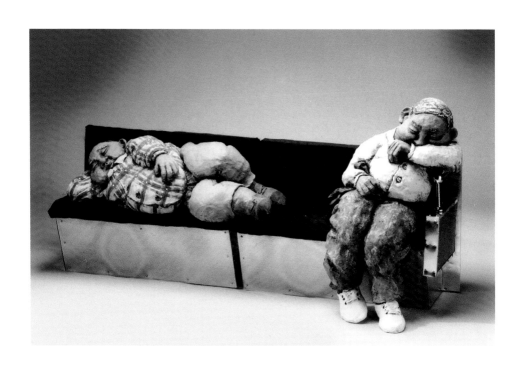

I feel dead tired 130×50×50cm Ceramics, Stainless steel 2002

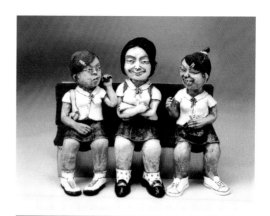

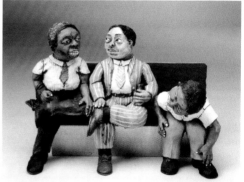

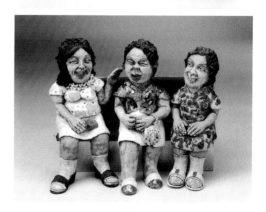

Talkative 50×25×40cm(ea) Ceramics 2002

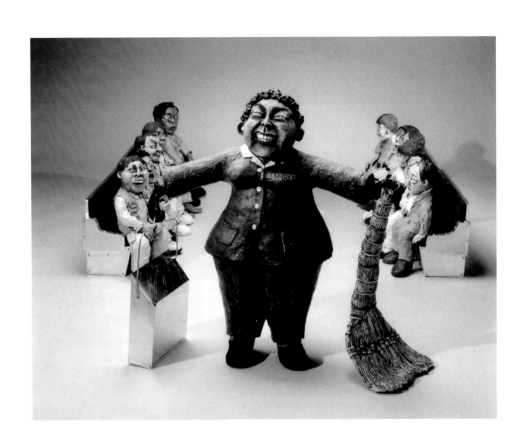

The end 200×200×80cm Ceramics 2002

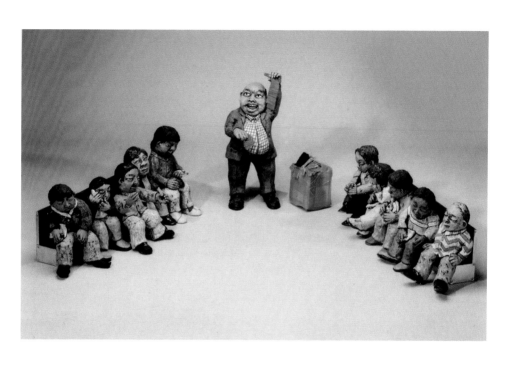

The president 150×100×30cm Ceramics, Mixed material 2002

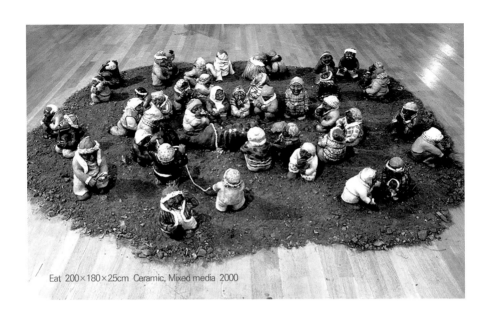

Eat 200×180×25cm Ceramic, Mixed media 2000

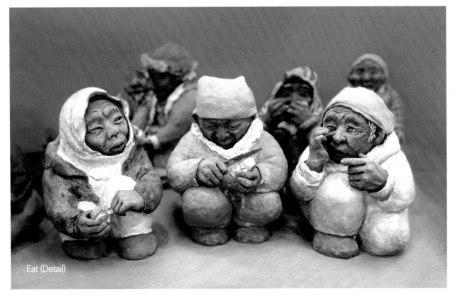

Eat (Detail)

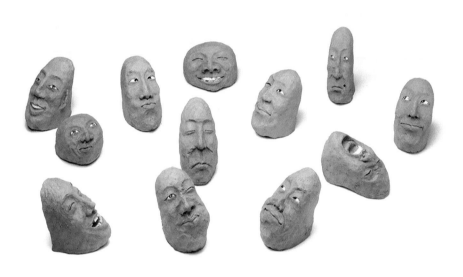

Face 100×60×15cm Terracotta 1997

자화상·가족
Self-portrait·Family
我·家人

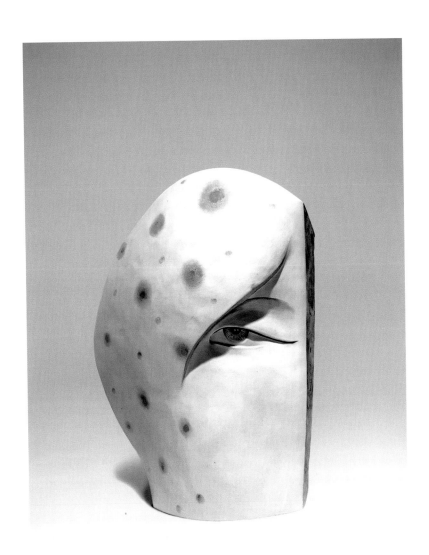

Rock 68×30×86cm Ceramic, Oil painting 2018

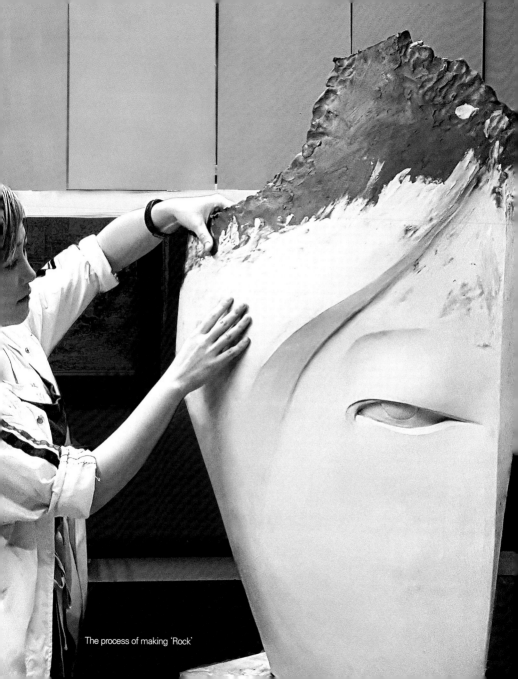

The process of making 'Rock'

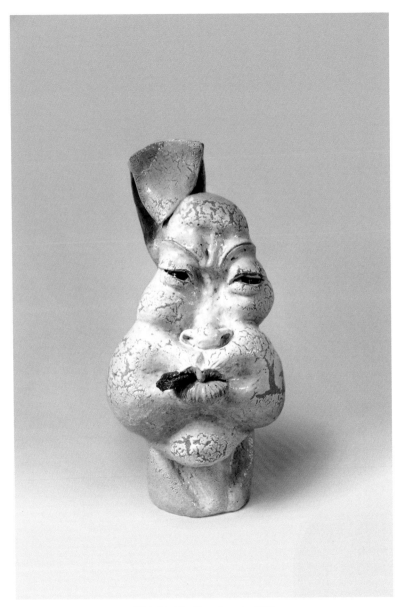

FULL 30×28×60cm Ceramics 2006

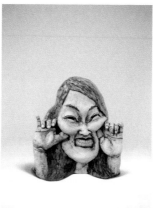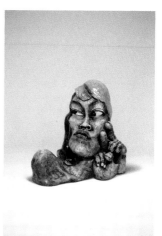

Self-portrait 45×33×60cm, 60×40×58cm, 65×35×58cm Ceramics 2006

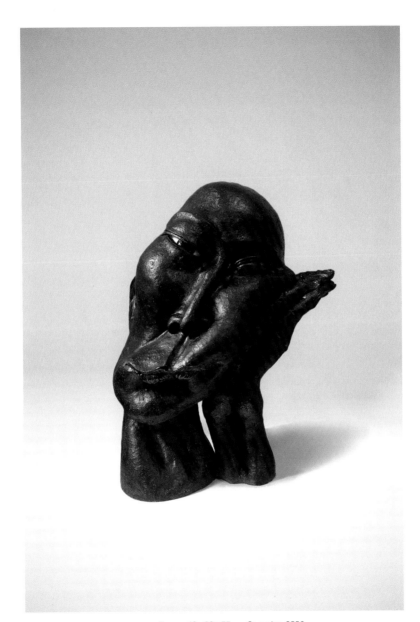

Dream 40×30×55cm Ceramics 2006

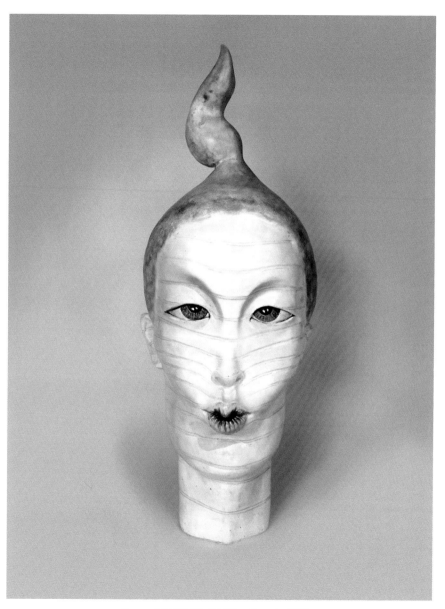

Gray age 灰色時代　30×35×63cm　Ceramics　2016

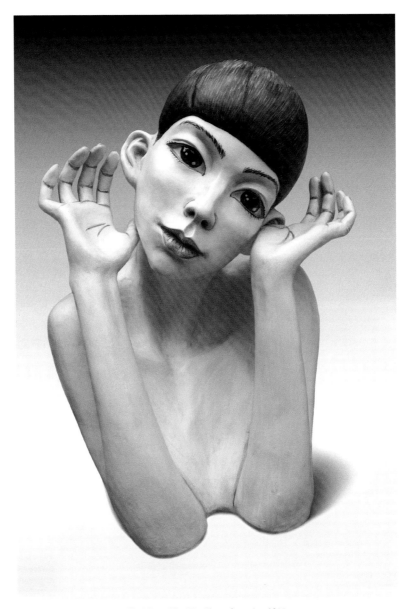

The Mirror 30×22×43cm Ceramics 2011

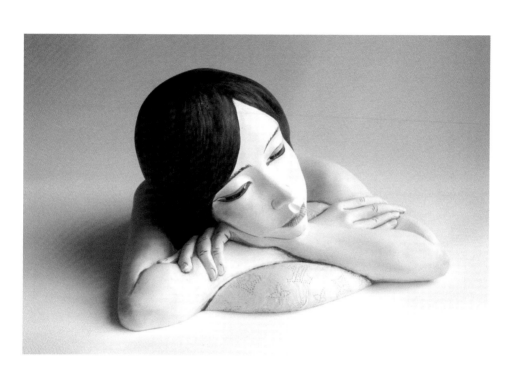

You 惑 35×30×20cm Ceramics 2011

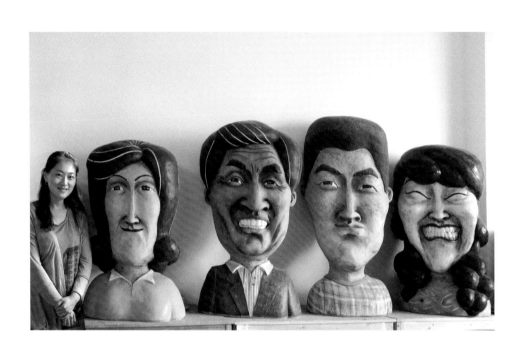

Family 500×70×135cm Ceramics 2008

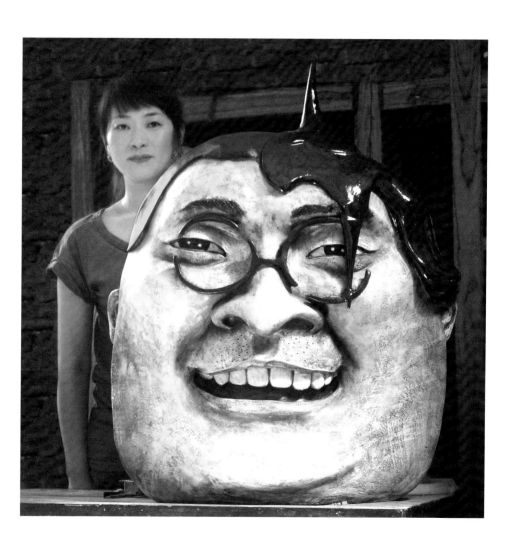

Scholar 98×30×110cm Ceramics 2011

자화상이나 가족을 만들면, 마치 의사에게 환자가 치료를 받 듯 스스로 마음의 외로움, 고단함과 아픔을 치유 받는 것 같다. (2008. 8 작가노트)

When sculpting self-portraits or families, I feel that I can heal myself from loneliness, rigors of life, and pain, as if a patient was being treated by a doctor. (2008. 8 Artist's notes)

我在制作自画像或家人时，就像医生为患者治疗一样，得到治愈自己的内心孤独、疲惫和痛苦。(2008. 8 艺术笔记)

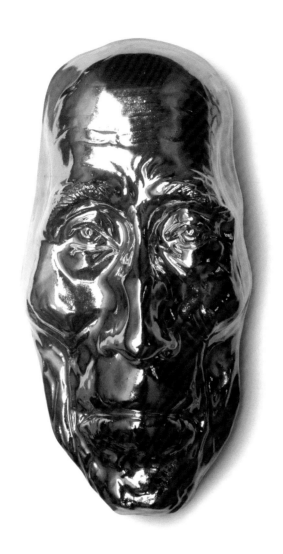

Rich 30×56×14cm Ceramics 2011

Profile

김생화

2011~현재 중국 광저우미술대학 공예미술대학
　　　　도예과 부교수
2016 홍익대학교 미술대학 디자인 공예학과
　　　도자전공 박사 졸업
2006 중국 칭화 대학교 미술대학 도예과 대학원 졸업
2003 홍익대학교 미술대학 도예과 및 동 대학원 졸업

개인전
2019 SAENGHWA KIM 2019 SOLO EXHIBITION
　　　(국립타이난예술대학/칭칭토기, 대만)
2018 '625 in USA' 김생화 개인전
　　　(K&P갤러리, 미국 뉴욕 첼시)
2017 'Day by day' 김생화 작품전
　　　(주명 스페이스, 중국 광저우)
2016 '漂' 김생화 작품전 (온도 화랑, 중국 광저우)
2015 'Look at yourself' 불산 도자예술제 특별초대전
　　　(용 공간, 중국 포산)
　　　'You look at yourself' 김생화 전
　　　(홍익대학교 현대미술관, 서울)
2013 '당신은 당신의 뒷모습을 볼 수 있는가?' 개인전
　　　(인사아트, 서울)
2012 '마음을 치유하는 곤충음악회' 김생화 초대전
　　　(KAIYI덴탈클리닉화랑, 중국 광저우)
2011 '음악을 듣고, 자연을 느끼다' 김생화 초대전
　　　(지메이 미술관, 중국 광저우)
2010 서울인형전시회 김생화 '도자 인형전' (코엑스, 서울)
2009 중국 불산 도자축제 개인전 (스완 공원, 중국 포산)
2002 '김생화'전 (한국공예문화진흥원, 서울)

전시
2019 말레이시아 현대미술관 20주년기념 국제학술 초청전
　　　(Daiichi Modern Art Gallery, 말레이시아)
　　　중화인민공화국 건립70주년 기념-광저우시
　　　미술가협회 조각예술위원회 학술전
　　　(광저우 텐허 문화예술센터, 중국)
　　　동아시아 예술의 문제-제2회 한중일
　　　현대예술 학술 초대전 (동관 화남 미술관, 중국)
　　　매력적인 중국-광동 문화주간 '꽃의 이야기'
　　　한중 여성화가 작품전 (서울 중국문화센터, 한국)
　　　국립창원대학교50주년기념국제교류전
　　　(창원대학교박물관, 한국)
2018 'SEE+光' Workshop & Exhibition
　　　(캘리포니아 롱비치 주립대, 미국)
　　　Interchange 국제초대전 (조현욱 아트갤러리, 한국)
2017 선전홍콩도시 건축 비엔날레 (선전 남두고성, 중국)
　　　산동우디국제정원조각전 (산동우디 신자위엔, 중국)
　　　아시아의 미래-현대 도자전
　　　(이천 도자CERAPIA전시실, 한국)
　　　아시아 현대 도예전 (아이치현 도자박물관, 일본)
　　　제1회 동관 공예전승과 창조전
　　　(똥관 명가구 박람회장, 중국)
2016 제3회 창녕 우포 공예예술인 협회전
　　　(창녕문화예술관, 창녕)
　　　광동성 대학 도예작품전 (포산 현대미술관, 중국)
　　　중국 (불산) 국제도예전 (스완 현대미술관, 중국)
　　　'合=人+一+口' 전 (가나아트스페이스, 한국)
　　　제5회 대학 아트페어 (광저우·파저우 박람회장, 중국)

2016 제10회 현대도자 청년 도예 비엔날레
　　(항저우 중국미술학원, 중국)
　　'자아의 서사' 한중일 현대 미술 초청전
　　(똥관 영남미술관, 중국)
　　한·중·독 교류전 (삼다도 화랑, 제주도)
　　중국북방도자예술대전(화북이공대학미술관, 중국)
　　강정 대구현대미술제 (강정 디아크, 대구)
　　아시아 현대 도예전 (타이난 대학, 대만)
　　'대기완성' 전 (광저우 미술대학, 중국)
　　예술 기물전 (Kui Yuan Gallery, 중국)
　　중국불산도자예술제아시아도예초청전 (포산,중국)
2015 ISCAEE 국제 도자 학술회 교류전 (이씽, 중국)
　　아시아 현대 도예 교류전 (중국미술학원, 중국)
　　'기물정신4' 한중 교류전 (포산 용 공간, 중국)
　　'봄' 예술 기물전 (Kui Yuan Gallery, 중국)
2014 광동성 대학 도예전(광저우 미술대학 미술관, 중국)
　　젊은 도예·유리전(홍익대학교 현대미술관, 서울)
　　아시아 현대 도예전 (클레이아크 김해미술관, 김해)
　　중국 경덕진 국제도자박람회 특별초대전
　　(징더전 도자박람회A홀, 중국)
　　한국, 프랑스 교류전 (아트컴퍼니긱, 서울)
2013 현대도자 청년 작가전 (중국미술학원, 중국)
　　아시아현대도예교류전(아이치현 도자박물관, 일본)
　　현대도예-내일에 대한 오늘의 이야기
　　(해강 도자미술관, 해강)
2012 제9회 현대도자비엔날레 청년작가초대전
　　(중국미술학원, 중국)
　　기물정신 한중교류전(포산신미디어산업전시장,중국)
　　아시아현대도예전(신베이시립잉거도자박물관,타이완)

2011 '신기루'국제현대도예전(샹하이 두랜드 미술관, 중국)
　　제3회 ART ROAD 77 아트페어
　　(헤이리12곳 갤러리, 헤이리)
　　'경계와 유혹' T2전 (진아트, 헤이리)
　　서울국제 캐릭터 콘텐츠 초대작가전 SICI
　　(윤슬 미술관, 사상 갤러리, 상원 미술관,
　　김해, 부산, 서울)
　　아시아현대도예교류전(포산스완도자박물관, 중국)
2010 'It's White' 홍익대학교 도예전공 석·박사전
　　(두산 Art Square, 서울)
　　아시아 현대 도예 신세대 교류전
　　(홍익대학교 미술관, 서울)
　　'현명한 아름다움: 공존의 아름다움(ECO ECHO)'
　　도어 그룹전 (한국 공예 디자인 문화진흥원, 서울)
2009 한중 현대 도예 교류전(포산 스완 도자박물관, 중국)
　　'陶花盛放' -여성을 소재로 한 도자작품전
　　(포산 스완 도자박물관, 중국)
　　아시아 현대 도예 신세대 교류전
　　(아이치현 도자박물관, 일본)
　　경덕진 현대국제도예전(징더전 중국도자박물관, 중국)
2008 제2회 현대도예 순회전
　　(닝보 미술관, 똥관 미술관, 우한 미술관, 중국)
　　한중일 현대도예 신세대 교류전 - '삼국연의'
　　(포산 현대도예미술관, 중국)
　　현대도예전(시안 미술관, 중국)
　　경덕진현대국제도예전(징더전중국도자박물관,중국)
　　'소통과 확산' 베이징 올림픽 기념 한중 도예
　　교류전(베이징 주중 한국 문화원, 중국)

2007 국제도예가작품전 (포산 스완 박물관, 중국)
　　　제2회 국제장작가마소성전 (포산스완남펑구자오, 중국)
　　　석완현대도자전 (포산스완중국현대도예미술관, 중국)
　　　한중현대도작가교류전 (베이징 구입방미술관, 중국)
　　　광동 현대도예대전 (광저우미술학원 미술관, 중국)
　　　광동성 제2회 도자예술창조, 디자인전
　　　(포산 스완 중국현대도예관, 중국)
　　　제1회 '경철국제도예&세계환경도자'
　　　(상하이 Jingzhe미술관, 중국)
2006 tsing hua art show (베이징 칭화대학교 미술관, 중국)
　　　제5회 현대도자비엔날레 (항저우 중국미술학원, 중국)
　　　제4회 중국 석만 도예문화제 '흙, 유약, 불-전통과
　　　예술의 융합' 전 (포산 스완 도자박물관, 중국)
2003 'MIX18' 전 (한국공예문화진흥원, 서울)
　　　'호호호' 전 (한국공예문화진흥원, 서울)
　　　'달을 닮은 달' 전 (청주공예비엔날레 국제공예
　　　상품 산업 교류관, 광주신세계갤러리)
2002 '누가 우리를 쓰레기라고 불렀나' 기획전
　　　(한국공예문화진흥원, 서울)
2001 Hongik ceramic art show
　　　(홍익대학교 현대미술관, 서울)
　　　세계도자 엑스포 토야랜드 프로젝트 참여 (이천)

수상
중국 광동성 대학 연합 도예 작품 공모전 1등(2016,
2014, 중국 교육부), 국제 생태 디자인 창의 콘텐츠
공모전 최우수 지도교수상(2018, 2016, 생태디자인
창의교육원), 경인미술대전 특선(2003, 부천 복사골
갤러리), 세계도자비엔날레 국제공모전 입상(2003,
세계도자엑스포), 서울 현대 도예공모전 입상(2003,
2002 서울갤러리), 익산한국공예대전 특선(2002,
익산 솜리문화예술회관), 관악현대미술대전 입상
(2001, 경기도 안양문화회관)

작품소장 및 보도자료
롱취안시 차오싱원(2020, 중국), 창원대학교 박물관
(2019, 한국), 캘리포니아 롱비치 주립대(2018, 미
국), 筑梦 아트 스페이스(2017, 중국 광저우), 용 공
간(2015, 중국 포산), 중국 정부 문화부(2015, 중국
포산), 지메이 미술관(2011, 중국 광저우), 두랜드 미
술관(2011, 중국 상하이), 스완 도자박물관(2011,
2010, 2007, 2006, 중국 포산), 중국 우한 미술관
(2009), 닝보 미술관(2008.8), Jingzhe미술관(2007,
중국 상하이), 스완 현대도자미술관(2007, 중국), 포
산 방송국 다큐멘터리(2007.6, 중국), 주장시 일보
(2007.5, 중국), 포산 일보(2007.5, 중국), 포산 일보
(2006.9, 중국), 한향림 갤러리(2003, 경기도 파주),
책 박물관(2003, 시대별 수업과정 인형, 대전), 전통
술 박물관(2001, 술 빚기 인형, 포천)

http://realhwa.com
E-mail: realhwa@naver.com/realhwa@qq.com

SAENGHWA KIM

Personal History

2016 Ph.D, Hongik University, Korea

2006 MFA, Tsinghua University, China
(Majored in Ceramics)

2003 BFA & MFA, Hongik University, Korea
(Majored in Ceramics)

Associate Professor,
Guangzhou Academy of Fine Arts, China

Solo Exhibition

2019 SAENGHWA KIM 2019 Solo Exhibition (Taiwan)

2018 '625 in USA' SAENG HWA KIM Solo Exhibition
(USA New York)

2017 'Day by day' KIM, SAENG HWA Solo Exhibition (China)

2016 'Bleach' KIM, SAENG HWA Solo Exhibition (China)

2015 'Look at yourself' KIM, SAENG HWA
Solo Exhibition (China)
'You look at yourself' KIM, SAENG HWA
Solo Exhibition (Korea)

2013 'Can you see your back?' KIM, SAENG HWA
Solo Exhibition (Korea)

2012 'Insect concert' KIM, SAENG HWA
Solo Exhibition (China)

2011 'Symphony of the Nature KIM, SAENG HWA
Solo Exhibition (China)

2010 Seoul Doll Fair 'KIM, SAENG HWA ceramic doll' (Korea)

2009 2nd China (Foshan) Ceramics Festival
Solo Exhibition (China)

2002 1st Solo Exhibition (Korea)

Exhibition & Career

2019 Daiichi Modern Art Gallery 20th Anniversary
International Academic Art Exhibition
(Daiichi Modern Art Gallery, Malaysia)
70th Anniversary of the Founding of the
People's Republic of China – The First Academic
Annual Exhibition of the Sculpture Art Committee
of Guangzhou Artists Association (Guangzhou
Tianhe District Cultural and Art Center, China)
'Artistic Problems in East Asia'—Second
Academic Invitation Exhibition of Contemporary
Art in China, Japan and Korea
(South China Art Museum, China)
'Flower Tales and Material Tales' - Joint of Chinese,
Japanese and Korean Female Painters' Works
Exhibition (Seoul China Cultural Center, Korea)
In celebration of the 50th anniversary of
Changwon National University 'International
Exchange Exhibition' (Cho Hyun Wook Art Hall,
Changwon University Museum, Korea)

2018 'SEE+光'Workshop & Exhibition at CCC(USA)
'Interchange'International Exhibition (Korea)

2017 Bi-City Biennale of Urbanism\Architecture (China)
Shan dong Wu di International Garden
Sculpture Exhibition (China)
The future of Asia Contemporary Ceramic Exhibition (Korea)
Contemporary Ceramic Art in Asia (Japan)
The 9th Gyeonggi International Ceramic Biennale (Korea)
The first Dongguan Craft and Creation Exhibition (China)

2016 The 3rd Changnyeong Upo Arts and Culture
Exhibition (Korea)
Ceramics Works Exhibition of Universities in
Guangdong (China)
China (Foshan) Siwan International Ceramic
Art Exhibition (China)
'Conjunction' Contemporary Art (Korea)
The 5th Graduates Art Fair Guangzhou (China)
The 10th China Contemporary Young Ceramic
Artists' Biennale (China)
The Art of 'East Asia' as the Issues, Narrative-Ego (China)
Korea·China·Germany Art Exhibition (Korea)
North China Ceramic Art Exhibition (China)
Daegu Contemporary Art Festival in Gangjeong (Korea)
Contemporary Ceramic Art in Asia (Taiwan)
blooming wares (China)
Utensils Exhibition (China)

2015 Shiwan Ceramics Dialogue with the World International
Exhibition Asian Ceramic Art Invitation Exhibition (China)
ISCAEE International Ceramic Exhibition (China)
Contemporary Ceramic Art in Asia (China)
4th Ceramic Ware Exhibition(China)
'Spring' Utensils Exhibition (China)

2014 Guang dong Education Institutions Ceramic
Exhibition (China)
Young Ceramic and Glass Exhibition (Korea)
Contemporary Ceramic Art in Asia
(Clayarch Gimhae Museum, Korea)
China Jingdezhen International Ceramics Exhibition (China)

2013 Contemporary Ceramic Art in Asia (Japan)
2012 Contemporary Ceramic Art in Asia (Taiwan)
9nd Ceramic Biennale Exhibition (China Academy Of Art)
Ceramic Ware Exhibition(China)
2011 'Mirage;Ceramic Experiments with Contemporary
Nomads' (China)
3rd ART ROAD 77 art fair - with art, with artist!
(Heyri Artist Valley, Korea)
'T2' Exhibition (Jin Art, Korea)
2010 'It's White' Ceramic Exhibition
(DOOSAN Art Square, Korea)
Contemporary Ceramic Art in Asia (Korea)
'ECO ECHO'The 8th Ceramic Exhibition of
DOOR Group (Korea)
2009 Korea and China Contemporary Ceramic
Exhibition (China)
Female subject Ceramic Exhibition (China)
Contemporary Ceramic Art in Asia (Japan)
Jingdezhen International Contemporary Ceramic
Exhibition (China)
2008 2nd China International Ceramic Exhibition
(China, Ningbo)
'The Romance of Three Kingdoms' Korea, China
and Japan Ceramic Exhibition (China)
Contemporary Ceramic Exhibition (China, Xian)
Jingdezhen International Contemporary Ceramic
Exhibition (China)
'Communication and Expansion' Korea and China
Ceramic Exhibition (China, Beijing)

2007 China Foshan International Ceramic Exhibition (China)
　　　Exhibition of the Wood-fired Art Works by the
　　　International Artists (China)
　　　Shiwan Contemporary Ceramic Exhibition (China)
　　　International Ceramic Exhibition (China)
　　　Guangdong Contemporary Ceramic Exhibition (China)
　　　2nd Ceramic & Design Exhibition (China)
　　　1st The First Jingzhe International Ceramic
　　　Exhibition (China)
2006 Tsing-hua art show (China)
　　　5nd Ceramic Biennale Exhibition (China Academy Of Art)
　　　4th Exhibition of Shiwan Ceramic (China)
2003 Exhibition 'MIX18' (Korea)
　　　Exhibition 'Pot for Eternity' (Korea)
　　　Installation Book Museum
　　　Exhibition of Chungju Crafts Biennale
　　　'Moon likes doll' (Korea)
2002 Kraft Promotion Foundation Exhibition (Korea)
2001 Installation 'Brew Rice Wine of Doll' in Drink Museum
　　　Hongik ceramic art show (Korea)

Prize & Awards

Guang dong Education Institutions Ceramic Competition(2016,2014, first place), International Ecology Design Creative Competition (2018, 2016, Best Advisor Professor Award), 20th Kyeong-in Arts Festival(2003), 3th World Ceramic Biennale 2003 Korea International Competition(2003), 23th Seoul Contemporary Ceramic Arts Contest(2003), 22ht Seoul Contemporary Ceramic Arts Contest(2002), 3th Korea Arts and Crafts Awards(2002), 5th Festival Desbeaux Art Modernes de Kwan-ak(2001)

Works in Collections

Longquan Chaoxingyuan(2020, China), Changwon University Museum(2019, Korea), Zhumeng Art Space(2017, China), Yong Space(2015, China), Ministry of culture of the Chinese government(2015), Jimei Gallery(2011, China), Shanghai Duland Gallery(2011, China), Shiwan Ceramic Museum(2011, 2010, 2007, 2006, China), Wuhan Gallery (2009 ,China), Ningbo Gallery(2008, China), Shanghai Jingzhe Gallery(2007, China), Shiwan Contemporary Ceramic Gallery(2007, China), Hanhyanglim Gallery (2003, Korea), Book Museum (2003, Korea), Drink Museum (2001, Korea)

Born in Korea, Artist based in China
E-mail: realhwa@naver.com/realhwa@qq.com

金生花

个人履历
2016 毕业于韩国弘益大学美术大学设计·工艺陶瓷专
　　 业获博士学位
2006 毕业于中国清华大学设计艺术学陶瓷专业，
　　 获硕士学位
2003 毕业于韩国弘益大学美术大学陶艺系，
　　 获学士与硕士学位
2011 年至今任职于广州美术学院工艺美术学院陶艺系
　　 外国高级专家教授，研究生导师

个展
2019 金生花个展(国立台南艺术大学、青青土气, 台湾)
2018 '625 in USA'金生花个展(纽约切尔西K&P画廊, 美国)
2017 'Day by day'金生花当代艺术展(筑梦艺术空间, 广州)
2016 '漂' 金生花当代艺术展 (温度空间, 广州)
2015 '看看你自己'金生花个展(庸空间, 佛山)
　　 '看你自己'金生花个展(弘益大学现代美术馆, 韩国)
2013 '你能看到你的背影吗' 金生花个展
　　 (首尔仁声艺术画廊, 韩国)
2012 '虫乐治心' 金生花陶艺展(凯怡牙科艺术馆, 广州)
2011 '听音乐，感自然'金生花邀请展
　　 (红砖厂高居中心展厅, 广州)
2010 首尔娃娃展 金生花'陶瓷娃娃展' (coex, 韩国)
2009 首届中国(佛山)陶瓷节个展
2002 '金生花'展 (韩国)

参展
2019 马来西亚第一现代美术馆20周年馆庆国际学术特邀展
　　 (Daiichi Modern Art Gallery, 马来西亚)
　　 庆祝中华人民共和国成立70周年一广州市美术家协
　　 会雕塑艺术委员会首届学术年展
　　 (广州天河区文化艺术中心, 中国)
　　 作为问题的东亚艺术一第二届中日韩当代艺
　　 术学术邀请展(华南美术馆厅, 中国)
　　 花语·物语-中日韩女画家作品联展
　　 (韩国首尔中国文化中心, 韩国)
　　 国立昌原大学校庆50周年纪念国际交流展
　　 (国立昌原大学博物馆, 韩国)
2018 'SEE+光'Workshop & Exhibition at CCC
　　 (加州州立大学, 美国)

Interchange 国际邀请展
(JO HYUN WOOKK ART HALL, 韩国)
2017 深港城市建筑双城双年展 (深圳南头古城, 中国)
　　 山东无棣国际田园雕塑展 (山东无棣鑫嘉源, 中国)
　　 亚洲之未来 - 现代陶艺展
　　 (韩国陶瓷财团利川CERAPIA 会议室, 韩国)
　　 中日韩现代陶艺展 (番地爱知县陶瓷美术馆, 日本)
　　 京畿道国际陶瓷双年展 (骊州世界生活陶瓷馆, 韩国)
　　 首届东莞工艺传承与创新展 (东莞名家局世博园, 中国)
　　 第三届昌宁牛浦工艺艺术家协会展
　　 (昌宁文化艺术馆, 韩国)
2016 广东省高校陶艺作品学院展 (石湾当代美术馆, 中国)
　　 中国(佛山)石湾国际陶艺展 (佛山当代美术馆, 中国)
　　 '合'当代艺术展 (GANA空间, 韩国首尔)
　　 第五届大艺博 (广州琶洲博览会场, 中国)
　　 第十届中国当代青年陶艺家作品双年展
　　 (中国美术学院美术馆, 中国)
　　 '自我叙事'中日韩当代艺术学术邀请展
　　 (岭南美术馆, 中国东莞)
　　 韩中德国交流展 (济州岛三多岛画廊, 韩国)
　　 '北方瓷韵-传承与创新'陶瓷艺术大展
　　 (华北理工大学美术馆, 中国)
　　 大邱江亭现代艺术节 (The ARC,韩国)
　　 亚洲现代陶艺新世代交流展 (台湾)
　　 '大器碗成'展 (广州美术学院雕塑馆, 中国)
　　 艺术器物展 (广州逵园艺术馆, 中国)
2015 中国佛山陶瓷艺术节亚洲陶艺邀请展 (佛山, 中国)
　　 ISCAEE 国际陶艺教育交流大会
　　 (清华大学美术学院, 中国)
　　 亚洲当代陶艺展 (中国美术学院, 中国)
　　 '寻花·问器'-器物精神004 (佛山大庸堂, 中国)
　　 '春' 艺术器物展 (广州逵园艺术馆, 中国)
2014 广东省高校陶艺作品学院展
　　 (广州美术学院美术馆, 中国)
　　 年轻陶艺玻璃展 (弘益大学现代美术馆, 韩国)
　　 亚洲现代陶艺交流展 (金海clayarch美术馆, 韩国)
　　 中国景德镇国际陶瓷博览会国际陶艺特展
　　 (景德镇国际陶瓷博览会场, 中国)
　　 亚洲现代陶艺新世代交流展 (莺歌博物馆, 台湾)
2013 中国当代青年陶艺家作品双年展 (中国美术学院, 杭州)

亚洲现代陶艺新世代交流展
(番地爱知县陶瓷资料馆, 日本)
亚洲现代陶艺新世代交流展 (石湾陶瓷博物馆, 中国)
第9届当代陶艺双年展 (中国美术学院, 杭州)
'器物精神'中韩交流展 (佛山媒体产业园, 中国)
2011 '海市蜃楼—游牧的丝绸之路实验' 国际当代陶艺展
(多伦现代美术馆, 上海)
第三届 ART ROAD 77 艺术节 – '和艺术, 和艺术家'
(韩国)
T2 陶艺展– '境界和诱惑' (韩国)
首尔国际动漫邀请展 SICI 2011 (韩国)
2010 'It's White'弘益大学陶艺专业硕博士生展
(斗山 Art Square , 韩国)
亚洲现代陶艺新世代交流展 (弘益大学美术馆, 韩国)
ECO ECHO展 (韩国工艺文化院, 韩国)
2009 中韩当代陶艺艺术交流展 (石湾陶瓷博物馆, 佛山)
'陶花盛放-女性题材陶塑珍品展'
(石湾陶瓷博物馆, 佛山)
亚洲现代陶艺-新世代交流展
(番地爱知县陶瓷资料馆, 日本)
景德镇当代国际陶艺展 (景德镇中国陶瓷博物馆,
景德镇)
2008 中国当代陶艺展第二季邀请函
(宁波美术馆, 杭州南宋官窑博物馆, 武汉美术馆,
莞城美术馆)
三国演义-2008年中日韩现代陶艺新时代交流展
当代陶艺展 (西安美术馆, 西安)
景德镇当代国际陶艺展
(景德镇中国陶瓷博物馆, 景德镇)
'沟通与扩散'纪念北京奥运会韩中陶艺交流展
(驻华韩国文化院, 北京)
2007 国际陶艺家作品联展 (石湾博物馆, 佛山)
第二届中国佛山国际陶艺柴烧作品展 (南风古灶, 佛山)
石湾当代陶艺展 (中国石湾当代陶瓷美术馆, 佛山)
中韩当代陶艺交流展 (九立方美术馆, 北京)
广东当代陶艺展 (广州美术学院美术馆, 广州)
第二届 广东省陶瓷艺术创作、设计创新作品展
(石湾中国当代陶瓷美术馆, 佛山)
第一届 惊蛰国际陶艺及世界环境陶艺展
(惊蛰美术馆, 上海)

2006 清华艺术展 (北京)
第五届中国当代青年陶艺家作品双年展
(中国美术学院, 杭州)
第四届中国石湾陶艺文化节作品展 '泥、釉、火-传
统与艺术的交融创作营' (石湾博物馆, 佛山)
2003 'MIX18'展 (韩国)
'好昊壶展' (韩国)
书博物馆制作偶人 (韩国)
清州世界陶艺展'Moon likes doll' (韩国)
2002 弘益计划展 (韩国)
2001 酒博物馆制作偶人 (韩国)
弘益陶艺展 (韩国)
世界陶艺展.'TOYA LAND'设计 (韩国)

获奖

广东省高校陶艺作品学院展一等奖(2016、2014, 中国广
东省教育厅), 国际生态设计创意公募大赛获得指导老师最
优秀奖(2018、2016, 韩国生态设计创意教育机构), 第20
届京仁美术大展(2003, 韩国), 第3届世界陶艺展国际公募
展(2003, 韩国), 第23届汉城现代陶艺公募展(2003, 韩国),
第22届汉城现代陶艺公募展(2002, 韩国), 第3届韩国工艺
大展(2002, 韩国), 第5届冠岳现代美术大展 (2001, 韩国)

作品收藏

龙泉市朝兴苑(2020), 国立昌原大学博物馆(2019), 美国加
州州立大学(2018), 中国广州筑梦艺术空间(2017), 庸空间
(2015), 中国政府与广东石湾博物馆(2015), 广州红砖厂高
居中心(2011), 上海都联美术馆(2011), 广东石湾博物馆
(2011、2010、2007、2006), 中国武汉美术馆(2009), 宁
波美术馆(2008), 惊蛰美术馆(2007), 石湾当代陶瓷美术馆
(2007), 韩国hyang-lim,han美术馆(2004), 韩国大田书博
物馆(2003), 韩国酒博物馆(2001)

个人网站 : realhwa.com
E-mail : realhwa@naver.com/realhwa@qq.com

HEXAGON 한국현대미술선
Korean Contemporary Art Book